MODERN ARTISTS

First published 2008 by order of the Tate Trustees
by Tate Publishing, a division of Tate Enterprises Ltd,
Millbank, London SW1P 4RG
www.tate.org.uk/publishing
© Tate 2008

A catalogue record for this book is available from the
British Library
ISBN 978 1 85437 623 7 (pbk)
Distributed in the United States and Canada by
Harry N. Abrams, Inc., New York
Library of Congress Control Number: 2006937949
Designed by Mr and Mrs Smith
Printed in Singapore

Front cover (detail) and previous page: PLOTS 1986, acrylic on
canvas, 182.9 x 182.9 (72 x 72)
Overleaf: NINE SWIMMING POOLS 1972, gunpowder, graphite
and watercolour on paper, 72.5 x 58.4 (29 x 23), private
collection
Measurements of artworks are given in centimetres, height
before width, followed by inches in brackets

Author's acknowedgements

Firstly I would like to thank Ed Ruscha, Paul Ruscha and
Mary Dean at the Ed Ruscha studio. Thanks also to
Lewis Biggs and Melissa Larner for their invaluable editorial
advice; to Robert Dean and Erin Wright, editors of the
Catalogue Raisonné; to Mark Francis and Hanako Williams
at Gagosian Gallery; and to Nicola Bion, Celeste Stroll,
Celia Clear, Roger Thorp, James Attlee and Anne Low at
Tate Publishing.

The biggest thanks of all are reserved for David Schweitzer,
without whose encouragement and endless good ideas
this book would not have been written at all. It is for him,
and for Arlo Schweitzer, who I hope will read it one day.

Artist's acknowledgements

Ed Ruscha would like to thank Mark Francis, Larry Gagosian,
Paul Ruscha, Mary Dean, Gregg Heine, Zoe Roché, Hanako
Williams, Anthony d'Offay, Mary Richards and everyone at
Tate Publishing.

ED RUSCHA

Mary Richards

Tate Publishing

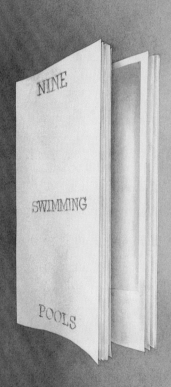

INTRODUCTION

Words have temperatures to me. When they reach a certain point and become hot words, then they appeal to me … Sometimes I have a dream that if a word gets too hot and too appealing it will boil apart, and I won't be able to read or think of it. Usually I catch them before they get too hot.[1]

Since the late 1950s, the American artist Ed Ruscha (who once had business cards printed 'Ed-werd Rew-shay' to aid pronunciation of his name) has worked in a variety of media – including painting, printmaking, drawing, photography, books and film. The result is a unique collection of works that is at once playful and profound ('I'm dead serious about being nonsensical', he has said).[2] Words and phrases are at the centre of his works, often set against a coloured or stained background or a monumental landscape. Through these simple means, he conjures up a world of associations.

This book traces the development of Ruscha's work across five decades, exploring its engagement with photography, Pop and Conceptual art, literature and cinema. It focuses in detail on key works, on Ruscha's techniques, materials and language, and on frequent themes, such as Los Angeles and the American West. His is not a practice of sudden breaks, but of subtle transformation; this book explores the internal logic of his oeuvre as words, images and phrases resurface time and again in new forms and shapes, like a recurring dream or the pieces of a jigsaw puzzle.

ARTISTS WHO DO BOOKS 1976 [1]
Pastel on paper
57.8 x 72.8 (23 3/4 x 28 5/8)
Tate and the National Galleries
of Scotland. Acquired jointly
through The d'Offay Donation
with assistance from the National
Heritage Memorial Fund and The
Art Fund 2008

E. RUSCHA 1959 [2]
Oil on canvas
110.5 x 110.5 (43 ½ x 43 ½)
Private collection

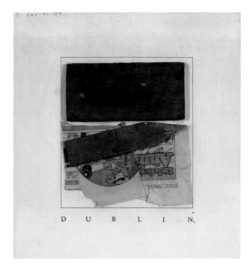

DUBLIN 1959 [3]
Wood, ink and newspaper
collage on paper
34.3 × 33 (13$\frac{1}{2}$ × 13)
Private collection

'ED-WERD REW-SHAY, YOUNG ARTIST'

Edward Joseph Ruscha IV was born on 16 December 1937 in Omaha, Nebraska. His father, Edward Joseph Ruscha III – the surname is of Bohemian/German extraction, probably a derivation of Ruschitzka – worked as an insurance auditor; his mother, Dorothy Driscoll Ruscha, who encouraged his interest in art, was of German/Irish descent. Ruscha describes his ancestry as 'real Middle America' – religious, with a strong work ethic. The family moved to Oklahoma City in 1941. Ed and his sister Shelby (who was a year older) and brother Paul (five years younger), with the exception of their schooling, were brought up as strict Catholics – a theme to which he would return in many of his works over the years.

As a boy, Ruscha discovered art through the unusual medium of Higgins India Ink. He recalls a neighbourhood friend, Bob Bonaparte, using this material in his cartoons: 'I remember seeing Higgins spill out on a piece of paper, and you could watch it dry up and crack … I had a real tactile sensation for that ink; it's one of the strongest things that has affected me as far as my interest in art.'[3] This fascination with the tools of the artist's trade would continue throughout his career. He would make work using the imagery of inks, paper and pencils, while his interest in 'tactile sensations' would lead him to explore the visual effects of organic or unusual substances – from rose petals and raw spinach stains to chocolate and gunpowder. Words, as we shall see, have been a constant theme for him, but giving those words material form has also been a key preoccupation.

The young Ed enjoyed drawing cartoons, painting and poring over his collections of stamps and coins. From these, he experienced the pleasure of labelling and classifying ('I liked to look at the stamps on the mail. I got a real feeling for envelopes, stamps on envelopes, cancellations, postmarks, typewritten type.')[4] He also delivered newspapers for the *Daily Oklahoman*, to which he attributes an interest in diagrams and street patterns. Ruscha and his close friend Mason Williams became known as 'the class artists' at Hawthorne Elementary School, and he recalls the pair spending 'practically the whole year' on a mural of the Oklahoma Land Run. Out of school hours, he attended a painting class with a local artist, Richard Goetz. 'His was the most traditional approach to art. We'd look out of the window and draw pictures of the houses across the street … I did have a leaning towards that, but my mind was off somewhere else – it was actually in comics.'[5] 'Constantly drawing cartoons', Ruscha enjoyed the work of illustrator Norman Rockwell (his father regularly took the *Saturday Evening Post*) and the cartoonist Basil Wolverton. The characters Dick Tracy, Blondie, Felix the Cat, and the Walt Disney movies were also favourites. As with fellow Pop artists Andy Warhol and Roy Lichtenstein, some of the comic book heroes he enjoyed in his childhood would later appear in his art.

In 1952, Ruscha hitchhiked with a friend across the Southern US states, visiting towns such as Dublin, Sweetwater and Vicksburg, peculiar names that would make their way into early paintings. The collage *Dublin 1959* (fig.3) and the 1960 painting of the same name show his interest in giving words centre stage. Here, the black type, which Ruscha hand-set in spaced capital letters, sits like a perplexing caption beneath two fragments of a painted picket fence and a cartoon strip, 'Little Orphan Annie', torn from a newspaper. Ruscha would later use the 'Annie' font in the paintings *Annie* 1962 and *Annie, Poured from Maple Syrup* 1966, p.48.

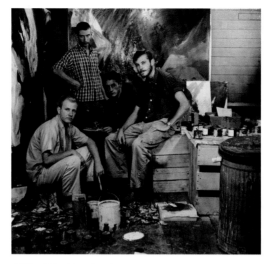

1818 North New Hampshire Avenue,
Hollywood, California, 1959 [4]
Clockwise from top:
Jerry McMillan, Patrick Blackwell,
Ed Ruscha, Joe Goode

Los Angeles

Ruscha set off on another road trip in August 1956. Attracted among other things by California's 'hotrods and custom cars', he took off, Kerouac style, to Los Angeles in his 1950 Ford with Mason Williams (who would become a successful writer and musician). Ruscha's destination was Chouinard Art Institute, now CalArts, where he would study graphic design. Chouinard was a 'bohemian' school with links to Disney (many of the studio's animators had trained there, and Walt joined the board of Trustees during the mid-1950s). Other Oklahoma friends, artists Jerry McMillan and Joe Goode, would also attend the school and achieve their own artistic success. Ruscha describes his journey West in cinematic terms:

In the early 1950s I was awakened by the photographs of Walker Evans and the movies of John Ford, especially Grapes of Wrath *where the poor 'Okies' (mostly farmers whose land dried up) go to California with mattresses on their cars rather than stay in Oklahoma and starve. I faced a sort of black and white cinematic emotional identity crisis myself in this respect.*[6]

Of course, the boys from Oklahoma were joining a long history of migration to California. Wide-scale promotion of the region's natural charms, climate and quality of life by city 'boosters' from the end of the nineteenth century onwards attracted generations of immigrants seeking health, prosperity and opportunity. Booms in the 1890s and 1920s were fuelled further by the discovery of oil, the advent of irrigation systems that made the arid fields habitable, and the expansion of railroads, streetcars and highways. The Dust Bowl and the Depression drove Midwestern farmers – like the Joads in Steinbeck's novel – away from their lands. The population of Los Angeles County grew from 100,000 in 1900 to one million in 1920, doubling to two million by 1930. In

the post-war period, the growth of the motor and aviation, and, of course, the movie industries, caused the population to swell still further; by the time of Ruscha's arrival in 1956, it was around five million. At this time, California's image as a place of Hollywood dreams had just been sealed by the creation of Disneyland in 1955.

Ruscha has discussed the immense shock of arriving in the city from his 'primitive' Bible Belt hometown. 'The first thing that hit me was the number of people that were coming here. In the late 1950s, there were something like a thousand people a day, net gain, bringing in 750 cars every day. I was overwhelmed by that, and also by the smog. The smog was very bad back then.'[7] Significantly, in his 1982 retrospective catalogue, he chose to put maps of the two cities inside the front and back cover: his hometown a neat grid with a clear centre; Los Angeles a sprawling conglomeration of densely housed districts linked by a vast network of freeways. In this city with no centre, a car was essential to navigate the terrain.

The other shock would be cultural. Los Angeles in the 1960s could boast a vibrant art scene. Ruscha began to hang out at Barney's Beanery, a popular watering hole for musicians, writers and LA artists including Billy Al Bengston, Bob Irwin, Kenny Price, John Altoon, Larry Bell, Craig Kauffman and Ed Moses, all of whom showed at the Ferus Gallery. Ferus, which began life at 736A North La Cienega Boulevard, was the fulcrum of the art scene.[8] Founded in 1957 by curator Walter Hopps and artist Edward Kienholz (maverick art dealer Irving Blum became a director in 1959), it mounted a stream of significant shows featuring both local and international artists, including the influential pairing of *Jasper Johns/Kurt Schwitters* in September 1960. Other galleries existed in the same spot. La Cienega was the place to be on Monday nights

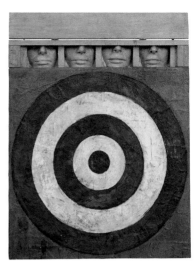

Jasper Johns
TARGET WITH FOUR FACES 1955 [5]
Assemblage
85.3 x 66 x 7.6 (33 5/8 x 26 x 3)
Museum of Modern Art, New York

for late openings, for a phenomenon known as the 'Art Walk', where galleries on both sides of the street would entice passers-by with booze and business.

The Golden State proved as much an influence on Ruscha as the art he discovered at Chouinard. For many critics, it is the connection to California that is the distinctive characteristic of his art. Although he famously (and nonchalantly) declared in a 1966 interview, 'Being in Los Angeles has had little or no effect on my work. I could have done it anywhere',[9] it is impossible to separate his art from the environment in which he has lived and worked for the past fifty years ('a city I love and hate at the same time'),[10] especially in a body of work that references so closely both the state's image as a natural paradise (its leafy vegetation, wide landscape vistas, bright sunlight and intense sunsets) and the effects of the manmade on its urban sprawl (neat rows of planted palms, billboards and road signs, apartment blocks, swimming pools, grid-like street networks, car parks, expansive highways, and resulting smoggy air). Recently, acknowledging the influence of the world around him, Ruscha compared his motivations as an artist to those of an agricultural worker: 'It seems like there's a desire to farm the landscape … you see the world as a possibility of things that you could grow and harvest.'[11]

When he first moved to LA, Ruscha lived with Williams on Sunset Place, off Lafayette Park; a few years later, he set up a house that doubled as a studio space with more fellow Oklahoma artists: Patrick Blackwell, Jerry McMillan, Joe Goode and Don Moore, also in Hollywood, at 1818 North New Hampshire Avenue. Here they created a darkroom where they would develop their own photographs. To fund his studies, Ruscha took various odd jobs including working for a printer, the Plantin Press, hand-setting type. A student oil, *E. Ruscha* 1959 (fig.2), spells the artist's name in

viscerally painted red, black and yellow letters that have the feel of printer's typesetting blocks. The painting also includes a self-conscious 'mistake': the letters 'H' and 'A' are squeezed above 'RUSC' since there is no space for them along the width of the canvas. The error is highlighted with the inclusion of a painted arrow.

At Chouinard, Ruscha took courses in advertising, design and photography, and published a student journal, *Orb*, which he mailed back to his brother Paul in Oklahoma. Eventually, he gravitated towards painting, but the influence of graphic design – the art of selecting type and image to create a visual message – would govern his work for the next fifty years. His four years at Chouinard were immersed in the dominant art form of the moment, Abstract Expressionism, under the tutelage of artists including abstractionists Robert Irwin, Richards Ruben and Emerson Woelffer. Though the students were conscious of the West Coast art scene, Ruscha noted, 'We got mainstream ideas from New York, from de Kooning and Franz Kline.'[12] He woke up to fine art by searching through books and magazines for works by the Dadaists, Duchamp, Man Ray and the proto-Pop of Jasper Johns and Robert Rauschenberg. A particular find was a small black-and-white reproduction of Johns's mysterious assemblage *Target with Four Faces* 1955 (fig.5) in *Print* magazine, an encounter that Ruscha has described as 'an atomic bomb in my training'.[13] Johns's presentation of everyday signs such as targets, flags and numbers, rendered in encaustic on layers of newspaper and fabric, was impersonal and ambiguous, offering no clues to the intentions of the artist. Critic Leo Steinberg in 1960 wrote of the new 'flatbed picture plane' created by Johns. In a radical break from the tradition of the picture as a vertical window on to the world, he said, the canvas could now be seen as a flat surface like a

table-top or printer's block, on which objects were collected, scattered or imprinted. This logic would also come to govern Ruscha's works; he was relieved to find an alternative to sitting in front of a blank canvas and waiting for inspiration. He commented:

Art school was Modernism, it was asymmetry, it was giant brush strokes, it was colors splashing, it was all these other things that were gestural rather than cerebral. So I began to move towards things that had more of a premeditation … The means to the end has always been secondary in my art. It's the end product that I'm after.[14]

Three Standard Envelopes 1960 (fig.6), like *Dublin*, can be seen as a synthesis of these early influences, and is typical of Ruscha's compositions of this period that incorporate splatters of paint within a neat, organised framework. The work contains six (real) envelopes – three closed, three open, collaged on to a page from a German newspaper. Out of their insides 'spill' unmistakeably Abstract Expressionist brushstrokes. We can see the influence of the German Dadaist Kurt Schwitters, whose work incorporated newspaper fragments, the detritus of the streets and other found objects. The title is perhaps also a reference to *Three Standard Stoppages* 1913–14 by Marcel Duchamp, another 'cerebral' artist. The work is notable for Ruscha's first use of the word 'standard', which would later crop up in his gas-station works (pp.24–5).

On leaving Chouinard in 1960, Ruscha, like Andy Warhol, entered the world of commercial design, in his case as a layout artist at the Carson/Roberts Advertising Agency in Los Angeles. He remembers creating a logo for Baskin Robbins ice cream, comprised of three silhouetted cones – the basic design of which is still used today. The immediacy of such designs, made to appeal to the new American consumer, would also be the foundation for Pop art.

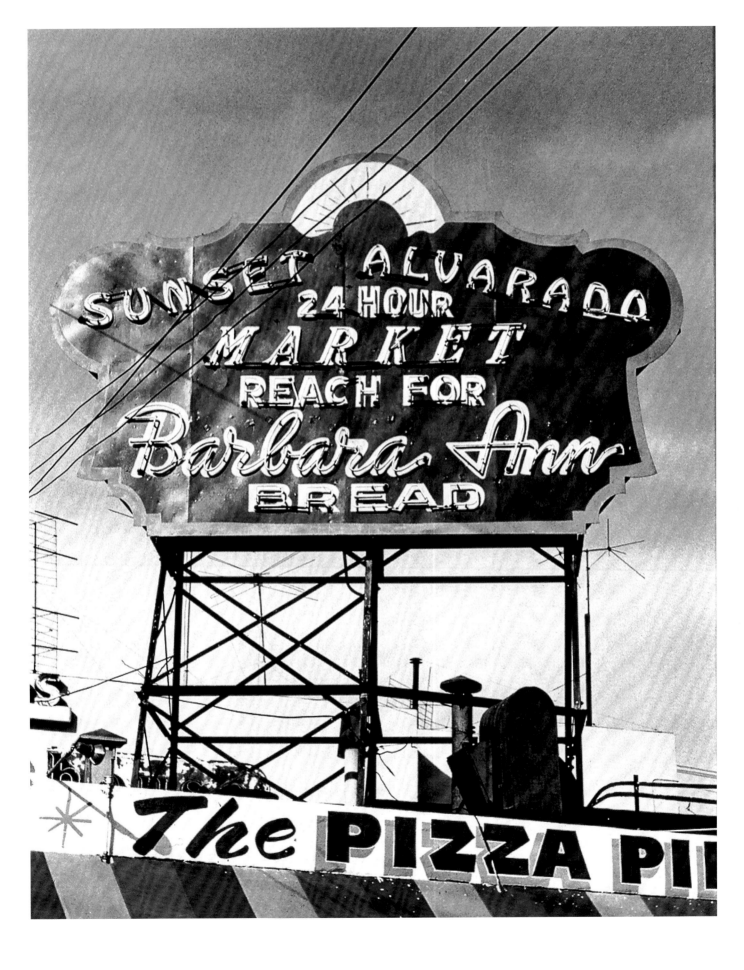

SWITZERLAND 1961 [8]
Gelatin silver print
12.7 x 10.2 (5 x 4)

FRANCE 1961 [9]
Gelatin silver print
8.9 x 8.9 (3 1/2 x 3 1/2)

Europe

In 1961, Ruscha travelled around Europe with his mother, and briefly his brother, a Grand Tour of sorts, and 'a big step in my education'.[15] They travelled in a Citroen that Dorothy Ruscha purchased in Paris, seen here decorated for Independence Day (fig.8). The expedition, from April to October, took in Italy, Greece, Yugoslavia, Austria, Germany, Belgium, the Netherlands, Denmark and Sweden, and finally England, Scotland and Ireland.[16] Ruscha documented his new surroundings not in a sketchbook but with his new Yashica twin-lens reflex camera, and had the pictures developed en route. ('I took pictures of things that I didn't see in the United States that had a rib-tickling effect on me.')[17] He was to find in Europe what European artists came to see in America: the iconography of the street – graphic road signs and street signs in odd typefaces, and curious shop-window displays featuring alien products. Such everyday subject matter would become the currency of Pop. He also had a keen eye for eccentricities, and in Europe he amassed a wealth of source material for the drawings and paintings he would create in subsequent years. A painted sign ('Total gasoline') is a notable feature of *France* 1961 (fig.9).

Through the lens of his camera, Ruscha also found a style that would later determine his photographic books (see *Twentysix Gasoline Stations* 1963, pp.32–3). His pictures were black-and-white, neutral, and often casually framed, though his subjects were carefully selected. They were generally of architecture or objects rather than human subjects. In particular, he captured diagonal perspectives and aerial views (see the shot of St Mark's Square in *Venice, Italy* 1961 (fig.11). His camera's box format and viewing mechanism were crucial in the appearance of the photographs: the machine was designed so that one must look down into its box, surveying the subject from above, rather than through a window directly on to the scene, the same 'flat-bed' view discussed by Steinberg. The viewfinder gave an incomplete picture of the scene, which meant that extraneous elements – shadows or, in some cases, even the feet of the photographer – would often creep into the frame. Ruscha chose not to crop or alter the photographs in any way, leaving such accidents or imperfections in view.

Ruscha's choice of photographic subjects displays the influence of photographers such as Walker Evans, Robert Frank, and even Eugène Atget. He remembers picking up a copy of Frank's own photo journey *The Americans* – published in the US in 1959, with an introduction by Jack Kerouac – and being intrigued by the immediacy of the pictures, and by the placement of pictures on the pages: a blank on the left-hand page, an image on the right, a formula he would follow in his own photographic books. Another influence was Evans's bird's-eye view from a rooftop on to a street of cars, *Main Street, Saratoga Springs, New York* 1931.

Pop Art USA

In October 1961, Ruscha returned home, stopping off in New York, where he met the prominent art dealer Leo Castelli and his assistant Ivan Karp, who showed him a Lichtenstein painting of a pair of sneakers (*Keds*) – an image appropriated from the world of advertising. Here, as he had witnessed in Europe, Pop art was beginning to take root, and the line between the commercial and art worlds was increasingly blurred. That year, Andy Warhol – still a commercial artist, and not yet represented by Castelli – exhibited five canvases as part of a window display at New York's fashionable Bonwit Teller department store. These took imagery from newspaper ads and *Popeye* and *Superman* comics. Meanwhile, in December 1961, Claes

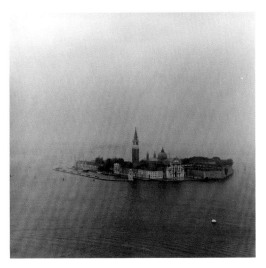

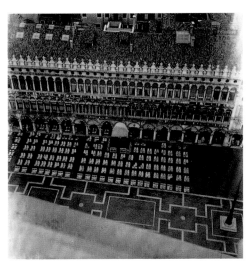

VENICE, ITALY FROM THE AIR
1961/2003 [10]
Gelatin silver print
25.4 x 25.4 (10 x 10)

VENICE, ITALY 1961 [11]
Gelatin silver print
8.9 x 8.9 (3 1/2 x 3 1/2)

Oldenburg created *The Store*, a sculptural installation of painted papier-mâché 'goods' displayed in a rented storefront on the Lower East Side. Works were sold directly to 'consumers' in an environment that mirrored the department store and circumvented the art gallery.

Critics have noted that the received history of Pop art has marginalised Los Angeles, despite the fact that two landmark Pop shows took place in the city in 1962.[18] Ferus presented the first exhibition of Warhol's Campbell's Soup paintings, curated by Irving Blum. The series of thirty-two canvases was lined up on a shelf, as if in a supermarket. In September of the same year, Walter Hopps curated his inaugural show as Director of the old Pasadena Art Museum (now the Norton Simon museum), *New Painting of Common Objects*. It was the first museum show in the United States dedicated to what would become known as Pop art. Ruscha designed the poster for the exhibition, according to Hopps, by dictating the text over the telephone to a commercial printer, with the instruction 'Make it loud!' Several of his works featured in the show, including *Box Smashed Flat (Vicksburg)* 1960–1 (fig.12) and *Actual Size* 1962 (fig.13). Both mix Abstract Expressionist gestural marks with a Pop sensibility. The central motif of *Box Smashed Flat* is the familiar figure of the grape picker on the Sun Maid Raisins packet – a vision signifying the health and abundance of California produce. The box is depicted as a flat net, squashed and smeared on the canvas, so that raisin juice emerges drip-like from within. In the lower half of the canvas, lettering spelling 'Vicksburg' (Mississippi, another stopover on his 1952 hitchhike) is partly obscured by a yellow wash of paint – introducing the bizarre relationship between word and image that would become his signature style. Ruscha would later produce paintings using stains from the juice of actual crushed foods, while the California maid would make another appearance in the lithograph *3327 Division* 1962 (he had moved his studio to this address in the Glassell Park area of LA in 1961).

In another work shown in the exhibition, *Actual Size* 1962, a painting of a can of Spam shoots like a rocket across the 'space' of the canvas. The word 'Spam', writ large in the upper half of the composition, suggests the sound that the little craft might make as it whizzes past – a domestic foreshadow of Lichtenstein's rocket *Whaam!* 1963. Ruscha's image perfectly fitted the show's title – a household product literally taking new form. The motifs of Spam and Sun-Maid Raisins were taken from a series of studio set-up photographs of domestic objects, which also included Sentinel Dental Floss, Campbell's Vegetable Beef Soup, Maja Soap (brought back from Spain), Wax Seal Car Polish, Oxydol detergent, Sherwin-Williams Turpentine and Monarch Rubbing Compound. Although later remade as a print edition entitled *Seven Products* 1961/2003 (fig.14), these works were preparations for paintings and not intended for exhibition, though they neatly anticipate Andy Warhol's own icons of domestic consumerism: serial paintings and sculptures of Campbell's Soup cans, Brillo boxes and Del Monte peach tins.

In the painting, the tin of Spam is indeed rendered *Actual Size* (the words of the title were etched into the yellow tail of the Spam-rocket), the product almost disappearing into the white space of the canvas. The same would be true for other common objects that Ruscha chose to illustrate: from comics and books to olives or marbles. ('When I choose an object, generally a small object, I can't render this object unless it is somehow faithful.')

Ruscha's Pop works also foreground an appreciation of language:

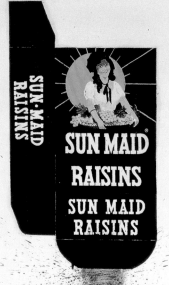
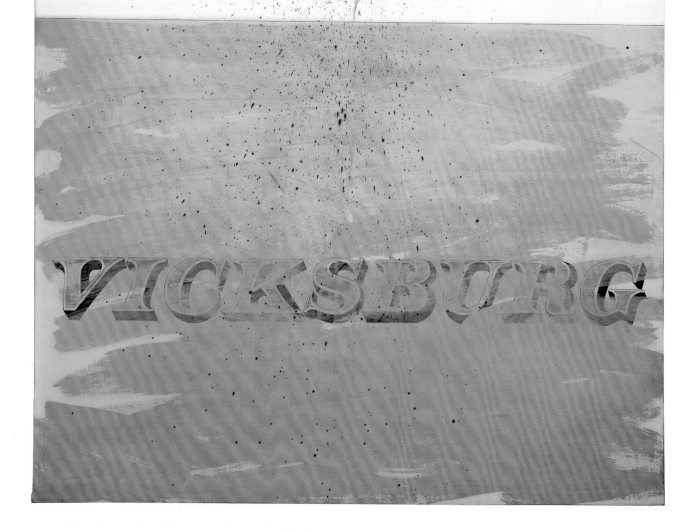

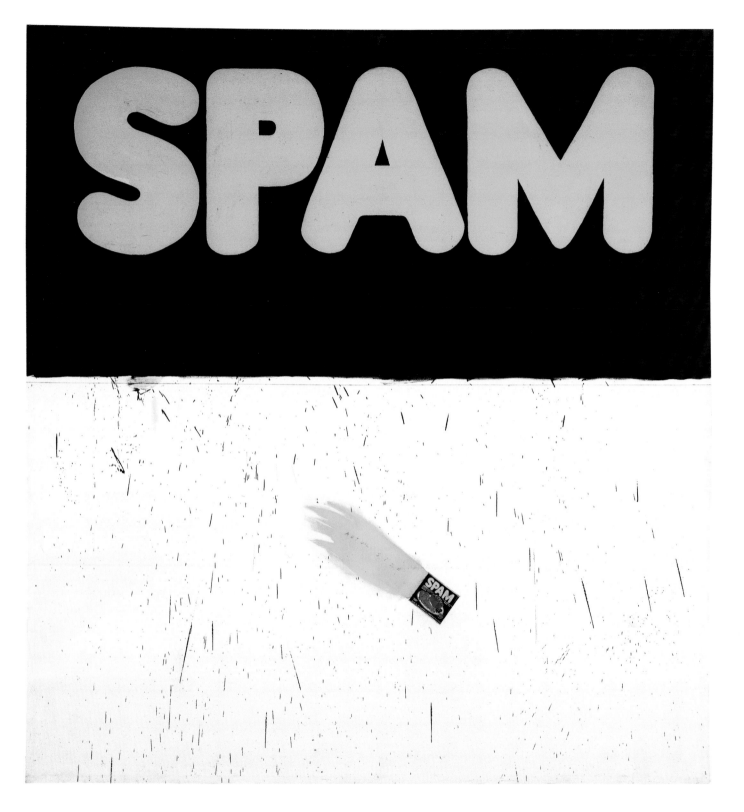

BOX SMASHED FLAT
(VICKSBURG) 1960–61 [12]
Oil and ink on canvas
177.8 x 121.9 (70 x 48)
Museum Ludwig, Cologne

ACTUAL SIZE 1962 [13]
Oil on canvas
182.2 x 170.2 (71³/₄ x 67)
Los Angeles County
Museum of Art

From SEVEN PRODUCTS 1961/2003
[14]
Gelatin silver prints
Each 33 x 25.4 (13 x 10)

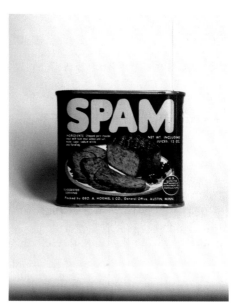

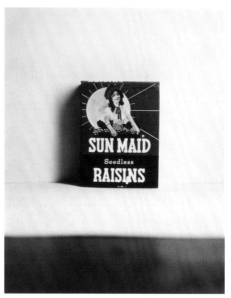

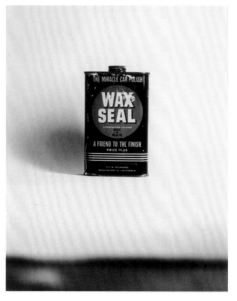

It was only the can and not the contents that inspired me. The word Spam ... and the sausage shaped letters I thought were beautiful together with that scary yellow ...[T]he word Spam is similar to the sound of a bomb. So you have this noisy thing at the top and then this projectile flying after the noise, arching across the sky like a shooting star'[19]

Boss, OOF, Honk, Ace, Smash, Flash: an inventory of paintings of the period reads like the soundtrack of a cartoon. Playing with the aural as well as the visual, often onomatopoeic or alliterative, alluding to comic-book violence, Ruscha's monosyllabic, hard-edged words don't just sit on the canvas but demand to be pronounced aloud. The lettering of Boss 1961 (fig.15) – actually a brand of workwear – stands alone, without an accompanying product, rendered in viscous paint on a chocolate-brown surface. The lemon-yellow eye-like discs of OOF 1963 (fig.16) are testimony to Ruscha's love of symmetry and patterned or repeated lettering, particularly the double 'o' (see Pool, p.55). They also echo the concentric circles of his favourite Jasper Johns painting, Target with Four Faces (fig.5).

Another 'loud' painting was the billboard-shaped Large Trademark with Eight Spotlights 1962 (fig.18), often used as the defining image of West Coast Pop. Taking as his subject the Fox studio's logo, familiar overture to many a film, Ruscha accentuated the diagonal perspective and transformed it into a monumental landscape. The drama of the composition is enhanced by the fact that little happens in the right-hand side of the picture, leaving all the 'noise' or action to take place on the left. The words appear as three-dimensional objects in space, like the famous sign in the Hollywood hills (also a Ruscha subject, pp.113–14); yellow, angular searchlights emanate from behind the monolith, shooting off in different directions. The work was included in Ruscha's first solo show at Ferus

in 1963. His second, in 1964, contained the three-metre-wide Standard Station, Amarillo, Texas 1963, a canvas based on a photograph from his book Twentysix Gasoline Stations (pp.32–3). He repeated the motif in a 1966 version of the painting (fig.19). Here, too, the picture is bisected by a diagonal line travelling from the bottom right-hand corner to the top left, creating a sense of dynamic movement ('the diagonal comes out of the idea of motion and speed, as well as perspective. When you divide the canvas like that you always have the suggestion of speed and depth').[20] Ruscha has said that he began to see everything from this point of view, even a loaf of bread. For this reason, his work has been compared to the Precisionists of the 1920s and 30s, who used a similar aesthetic to depict the modernity of industrial America (see Charles Sheeler's photographs and paintings of the Ford Motor Company plant in River Rouge, Michigan).

Ruscha often stresses that for him, line, colour and composition are as important as the subject of the painting. ('On the way to California, I discovered the importance of gas stations. They are like trees because they are there. They were not chosen because they were pop-like but because they have angles, colors and shapes, like trees.')[21] Although the text on the gas pumps is meticulously observed, most elements of naturalism have been eradicated, and the structure as a whole hovers in a dream-like space. The word 'Standard', of 'Standard Oil', is boldly rendered, catching the viewer's attention in a similar way to Ruscha's other 'word' works.

Ruscha's Pop paintings would also feature in the 1963 exhibitions Pop Art USA at Oakland Art Museum and Six More ... at the Los Angeles County Museum of Art, a 'West Coast' response to the Guggenheim's New York Pop show Six Painters and the Object.

BOSS 1961 [15]
Oil on canvas
180.6 x 170.5 (71 1/8 x 67 1/8)
The Eli and Edyth L. Broad
Collection, Los Angeles

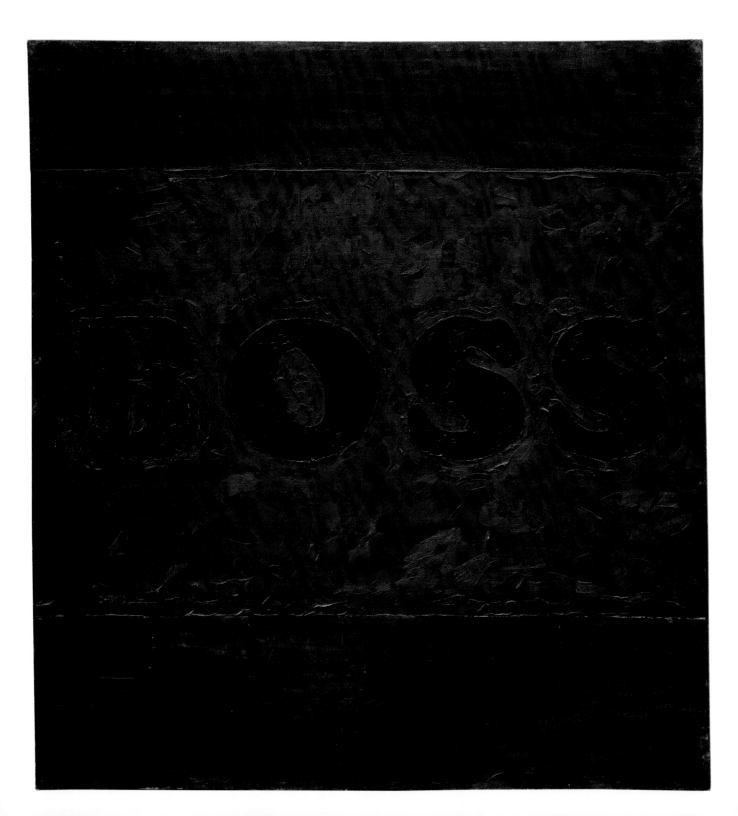

OOF 1962–3 [16]
Oil on canvas
181.6 x 170.2 (71 ½ x 67)
Museum of Modern Art, New York

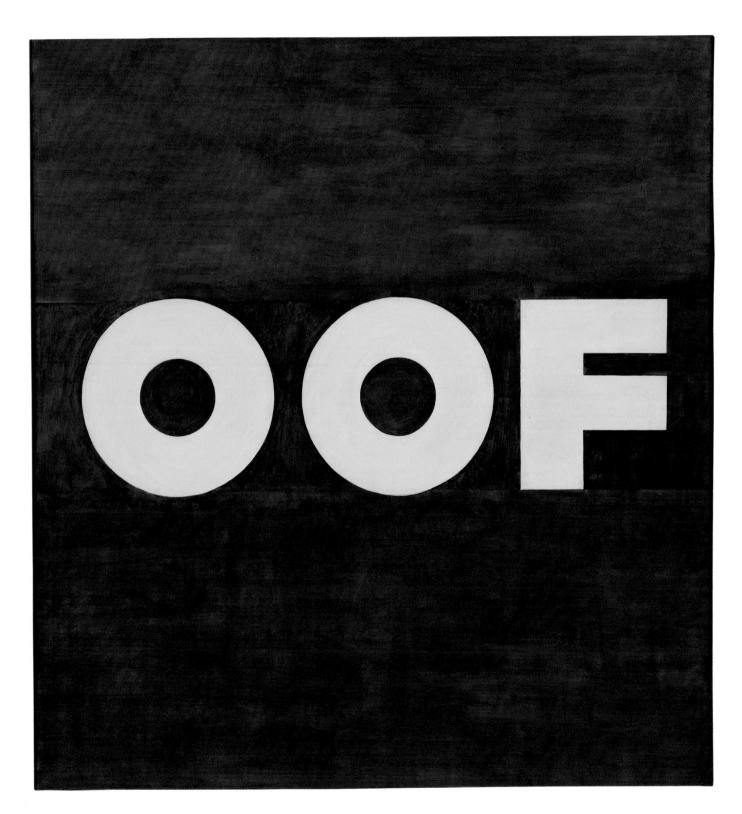

When discussing his work today, Ruscha often refers back to his childhood or his early years in Los Angeles. The themes explored in this chapter would continue to occupy him for five decades. Cartooning in Higgins ink would lead to tactile prints; the 'table-top' or aerial view, with reference to the city grid, in particular its harsh diagonal lines, would continue to influence the composition of his photographs and paintings. He would pursue the idea of foregrounding words in art, in particular with consideration to their aural as well as their visual impact. And he would continue to represent the city of Los Angeles. There would be many variations on these themes throughout his career, but they can often be traced back to this time. Although he achieved his first artistic success in the world of Pop art, even in 1963 we can see that these other interests would push him far beyond the boundaries of that movement.

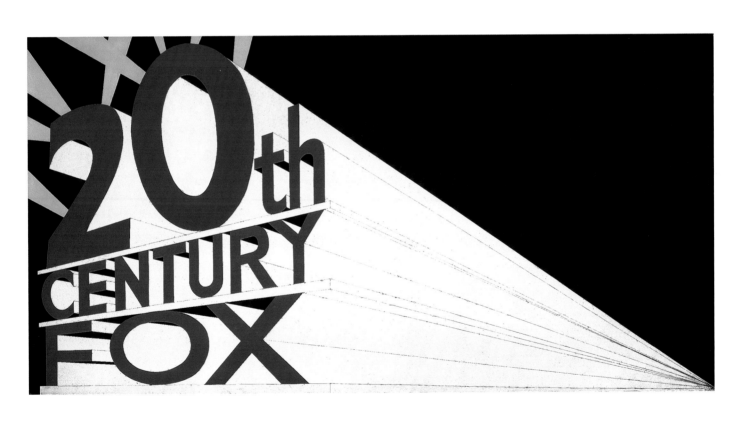

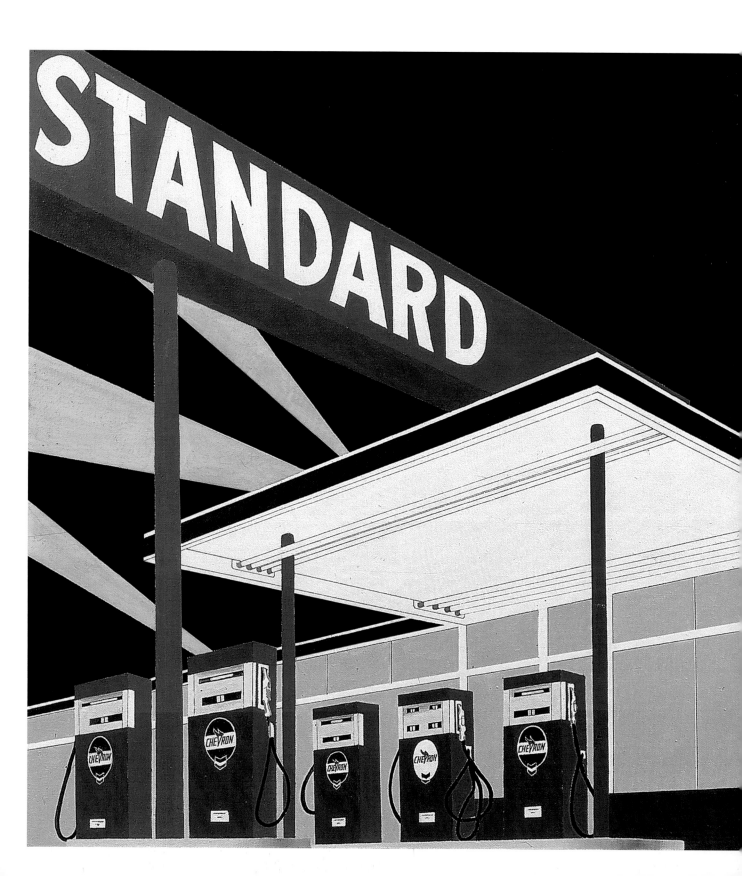

Noise, Pencil, Broken Pencil, Cheap Western is an inky blue canvas on to which the four elements of the title are arranged, collage-like, around its outer edges. The word 'noise' is placed at the upper edge of the painting. Its red letters are given the illusion of being 'projected' in three dimensions, as in *Large Trademark with Eight Spotlights* (fig.18). Two yellow pencils, one whole, one snapped in half, appear on the left and right hand sides of the work, their leads pointing outwards. At the bottom of the picture a 'Popular Western' comic balances on one of its corners. The comic would later be pictured 'torn in half' in *Standard Station, Ten-cent Western Being Torn in Half* 1964.

The painting synthesises many of Ruscha's interests at this time, both in terms of composition and subject matter. There is a neutral background that serves as a backdrop to the drama taking place on the canvas. The objects are lying flat in a table-top formation. Like the title of an earlier painting, the pencils and the comic are 'actual size', highlighting his interest in space and proportion.

The work appears to be about sound and the various signs that can be deployed to represent it. The word 'noise' is written in Ruscha's favourite slanting perspective, which, he has said, creates the impression of a speeding train rushing past. A breaking pencil makes a sound, of course, as does the Western comic-book – on the front of it a cowboy holds a smoking gun. Ruscha discussed the metaphor of noise in a 1990 interview with Bernard Blistène:

I guess the idea of noise, of visual noise, somehow meant something to me, and still means something to me. The idea that you can say a lot in a small given area somehow has always intrigued me, and this seems to be one of the principal guidelines in my work. I never forget that I have a given space in which to make a noise.[22]

Taking this quote as a starting point for an essay on Ruscha's phonic playfulness, critic Yve-Alain Bois posits that the painting doesn't attempt to render noise visually but 'toys with the excruciating difficulty of doing so'. In the 1990s, Ruscha would literally explore the idea of rendering noise visually by painting waveforms (see pp.86–8).

MARY RICHARDS In a page of your notebook, dated 22 April 1963, you wrote of the significance of *Noise, Pencil, Broken Pencil, Cheap Western*: 'This is by far the most exciting painting I have done to date – as I thought, it seems to have invalidated all my other paintings.' Do you remember writing that?

ED RUSCHA Yes. I felt that work was a thorough statement. The juice of it, I felt was right. Others of my works don't feel the same way. Works of art are like children. Each one is going to be a little different from the next. I'd done other works at the same time, using the motif of before and after: here it is before, and here it is after, like the pencil when it's broken in half. The idea of a broken pencil reminded me of a stage set, or an aerial photograph of some trivial occurrence. I mean, there are two simple, stupid objects that seemed to beg to be captured, or recorded. And the idea was doing that – capturing them and recording them, fitting them into this

picture in such a way that they almost look as if they're leaving the picture. They're on the outside edges, scrambling to get away from the centre of this domain that is the picture, which is made of wax and paint. So I just felt that one particular painting said it for me, and I felt very good about it. I still have that magazine that I painted today.

MR The Western?

ER Yes, it's like an old pulp magazine that was made back in the forties or fifties. And it just somehow inspired me to make that painting.

MR The painting combines lots of elements that you were exploring at the time: comics, sound, violent gestures, typographical or design space. Did it come out of the things that you were thinking about at Chouinard?

ER It comes from different points of my interest in things as an artist. And somehow I always fit it into these word-projects that I did, the single-word paintings. I came to appreciate the fact that words are set out in a horizontal landscape. I mean, they read horizontally, don't they? They don't read vertically. I always liked this stroking, side by side, almost like a robotic statement. My paint strokes are that way, even today.

MR You mean horizontal?

ER Yes, like in the backgrounds. The backgrounds are put on with paint, but they're done side by side, very robotically. So the words are actually spilling out across this picture in much the same way. And those things came to me through . . . God knows where – maybe poetry, or an interest in abstract forms. When you stare at them long enough, words become so inane. You can't recognise what they are. It's a matter of investigating some puzzle and never really having the answer. So each one of those things is like an exploratory venture.

MR I've always liked what you said about words having temperatures, and trying to capture them when they become boiling hot.

ER Yes, they possess a certain power, or a lack of power. I like the suspended animation of the whole thing. It's not necessary for a word to be hot, or powerful. It might lack all that too, but it has some sort integrity that gives it a reason for being subject matter.

MR Do you find that particular words have particular associations with shapes, forms or colour?

ER Yes. Early on, when I was doing my first paintings, I liked the monosyllabic, 'boss'. I liked that word, and it meant various things to me – it wasn't really a limited definition. 'Boss' could mean, 'Hey that's great!' So someone might like the shirt you're wearing and say, 'Wow, that's boss!' Another aspect of it was that it was a well-known brand of work clothes. It also meant your employer. And it was a verb, meaning to order someone around. But it wasn't the multiplicity of its meanings that gave it power. It's somehow the roundness of the whole thing – and the 'S's and the 'B' and the 'O'. It was almost beautiful like a tulip would be beautiful. Somehow that's where all of this inspiration is contained.

NOISE, PENCIL, BROKEN PENCIL,
CHEAP WESTERN 1965 [20]
Oil on canvas
181 x 170.2 (71 1/4 x 67)
Virginia Museum of Fine Arts, Richmod

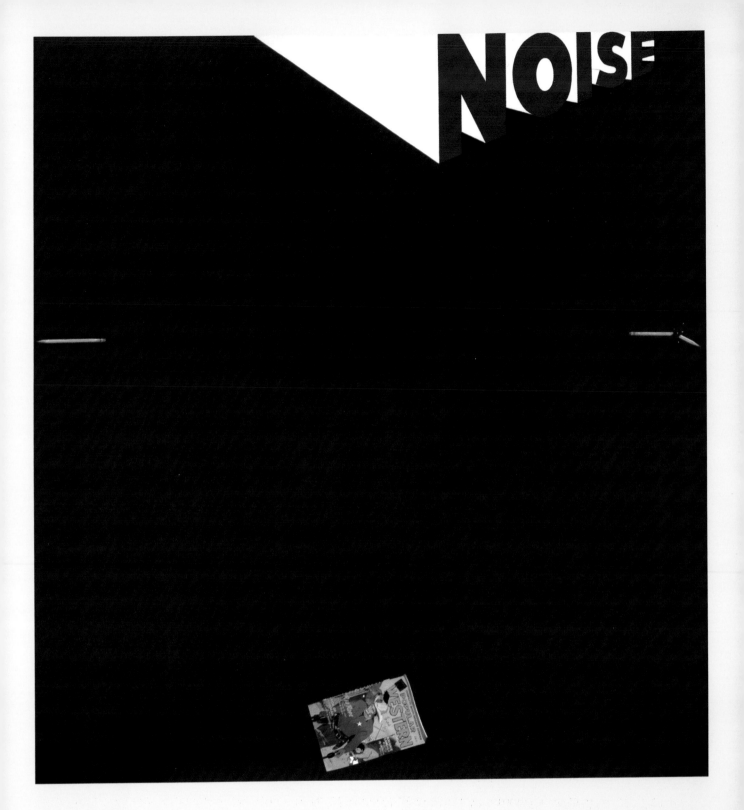

Ed Ruscha covered with
twelve of his books [21]
Photo by Jerry McMillan

2

'ARTISTS WHO DO BOOKS'

In 1963, Ruscha published *Twentysix Gasoline Stations* (fig.22), the first of seventeen books that he would produce under his own imprint throughout the 1960s and 70s. It's a modest, sparsely designed volume, comprising forty-eight pages and measuring 7 x 5 inches. The cover is minimal (white, with the title in red type) and, true to its word, the book contains twenty-six black-and-white photographs of gas stations, beginning with 'Bob's Service, Los Angeles, California', and ending with 'Fina, Groom, Texas'. The photographs were selected from the 'sixty or seventy' taken by Ruscha along Route 66, on trips to and from Los Angeles to his parental home in Oklahoma City – taking in Arizona, New Mexico and Texas en route.

Captioned only with the gas station's name and location, the photographs are largely similar in composition and crop. They are casually framed, often including a fair proportion of road or shadow in the foreground. All are devoid of people (a fact, Ruscha notes, that was pointed out to him by Andy Warhol when he gave him a copy of the book). The pictures do not document a particular journey, and there is no sense of narrative. Although they are organised geographically (Los Angeles–Arizona–New Mexico–Texas–Oklahoma), the last shot is out of sequence to emphasise the book's ending – 'Fina, Groom, Texas' ('final'). Looking at the stations, one experiences a sense of striking uniformity: the highway stretches for miles, but the view from the roadside is the same.

Ruscha's use of serial snapshot imagery, his urge to diagram, list and classify, and his wry sense of humour, are common themes in all his books. All are photographic, with minimal text (the obverse of his paintings, which tend to favour words over images). As inventories of similar subjects, most reproduce 'dry' exterior views with rarely any human presence. One can often visualise the contents of these photo essays from their titles: *Some Los Angeles Apartments*, *(Every Building on) The Sunset Strip*, *Thirtyfour Parking Lots*, *Nine Swimming Pools (and a Broken Glass)* and *A Few Palm Trees*. A smaller group of books, which involved collaboration with other artists, have more of a narrative thrust, and are often described as 'capers': *Crackers*, *Business Cards*, *Royal Road Test* and *Hard Light*.

'Huh?'

Seemingly artless, without a directly perceivable message, Ruscha's books were initially something of a puzzle. In fact, the puzzle was part of the point ('I realised for the first time this book has an inexplicable thing I was looking for, and that was a kind of a 'Huh?' That's what I've always worked around.')[23] He was at first keen to downplay the 'photographic' nature of his practice. In early interviews he stressed the books' random, snapshot aesthetic, dismissing the notion that they had any status as art. Instead, he emphasised the fact that it is the idea – rather than his authorship or the artistic qualities of the photographs – that is paramount:

The first book came out of a play with words. The title came before I even thought about the pictures. I like the word 'gasoline' and I like the specific quality of 'twenty-six'. If you look at the book you will see how well the typography works – I worked on that before I took the photographs. Not that I had an important message about photographs, or gasoline, or anything like that – I merely wanted a cohesive thing. Above all, the photographs I use are not 'arty' in any sense of the word. I think photography is dead as a fine art; its only place is in the commercial world, for technological or informational purposes. I don't mean cinema photography, but still photography; that is, limited edition, individual hand-processed photos. Mine are simply reproductions of

TWENTYSIX

GASOLINE

STATIONS

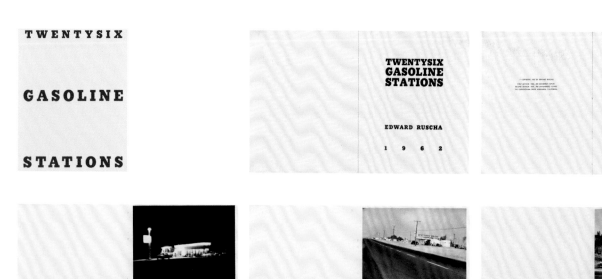

TWENTYSIX
GASOLINE
STATIONS

EDWARD RUSCHA

1 9 6 2

TO PATTY CALLAHAN

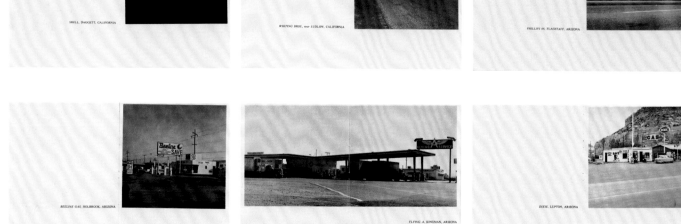

SHELL, DAGGETT, CALIFORNIA

WHITING BROS, near LUDLOW, CALIFORNIA

PHILLIPS 66, FLAGSTAFF, ARIZONA

BEELINE GAS, HOLBROOK, ARIZONA

FLYING A, KINGMAN, ARIZONA

DIXIE, LUPTON, ARIZONA

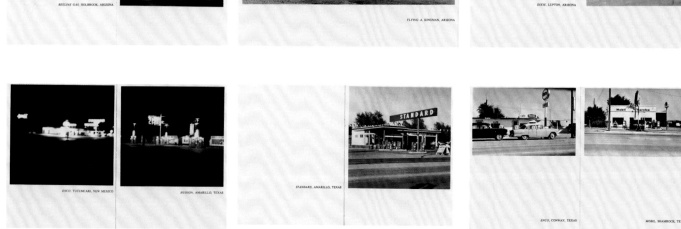

ENCO, TUCUMCARI, NEW MEXICO

HUDSON, AMARILLO, TEXAS

STANDARD, AMARILLO, TEXAS

ENCO, CONWAY, TEXAS

MOBIL, SHAMROCK, TEXAS

FINA, GROOM, TEXAS

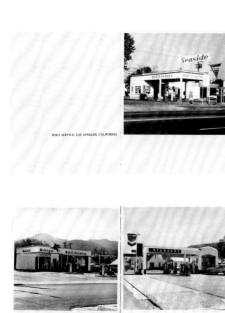

BOB'S SERVICE, LOS ANGELES, CALIFORNIA

TEXACO, SUNSET STRIP, LOS ANGELES

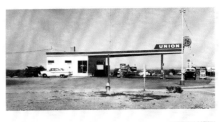

UNION, NEEDLES, CALIFORNIA

MOBIL, WILLIAMS, ARIZONA

STANDARD, WILLIAMS, ARIZONA

TEXACO, JACKRABBIT, ARIZONA

EL PASO, WINSLOW, ARIZONA

JIMMY JIM'S CHEVRON, JIMMY JIM'S, ARIZONA

SELF SERVICE, MILAN, NEW MEXICO

CONOCO, ALBUQUERQUE, NEW MEXICO

CONOCO, SAYRE, OKLAHOMA

TEXACO, VEGA, TEXAS

APCO, OKLAHOMA CITY, OKLAHOMA

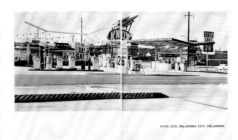

KNOX LESS, OKLAHOMA CITY, OKLAHOMA

TWENTYSIX GASOLINE STATIONS
1963 [22]
Book
17.9 x 14 ($7\frac{1}{16}$ x $5\frac{1}{2}$)

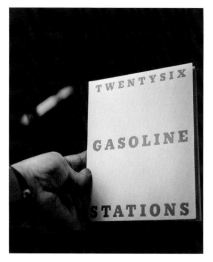

HAND SHOWING BOOK COVER
(TWENTYSIX GASOLINE STATIONS)
1963 [23]
Gelatin silver print
24.1 x 19.5 (9 1/2 x 7 5/8)

photos. Thus it is not a book to house a collection of art photographs – they are technical data like industrial photography. To me, they are nothing more than snapshots.

One of the purposes of my books has to do with making a mass-produced object ... My pictures are not that interesting, nor is the subject matter. They are simply a collection of 'facts'; my book is more like a collection of 'readymades'.[24]

One of the masters of 'Huh?' (and another lapsed Catholic), Marcel Duchamp, invented the term 'readymade' to describe a series of works in which appropriated objects were transformed by their presentation in the gallery. Most famous was the controversial exhibition of his 1917 sculpture *Fountain* at New York's Armory Show. The piece, a factory-made urinal upturned and placed on a plinth, he signed 'R. Mutt'; in the uproar that followed, he argued that this work was art because he had *chosen* it and designated it as such.

Duchamp has long held a fascination for Ruscha, for the simple reason that 'he discovered common objects and showed you could make art out of them'.[25] As well as the publication of *Twentysix Gasoline Stations*, 1963 also saw a seminal Duchamp exhibition, curated by Walter Hopps, at the Pasadena Art Museum. The first ever US retrospective of this key figure of twentieth-century art attracted attention from far afield – artists from New York (including Jasper Johns, Claes Oldenburg and Andy Warhol) made the journey across to California, and, from Britain, Richard Hamilton took his first trip to the States. Photographs of Duchamp posing in the gallery playing chess with a naked model, the writer Eve Babitz – who could later be found in Ruscha's photo-essay *Five 1965 Girlfriends* – captured the artist's sense of fun. Duchamp famously proclaimed that he had given up art for chess, and in these images it wasn't hard to see why.

Duchamp was a key influence on the emergence of Conceptual art later in the 1960s. Artists grouped under this broad title increasingly questioned the nature of art, the role and status of the artist, and the capitalism of the art world. As set forth in artist Sol LeWitt's essay 'Paragraphs on Conceptual Art' (published in *Artforum*, Summer 1967) – which included an image of Ruscha's (*Every Building on*) *The Sunset Strip* 1966 (pp.44–7) – a greater currency was given to the idea on which the art was based, rather than its final form; during this period, art made from cheap or transient materials could therefore flourish outside of traditional gallery spaces. LeWitt wrote:

In conceptual art the idea of concept is the most important aspect of the work ... all of the planning and decisions are made beforehand and the execution is a perfunctory affair. The idea becomes a machine that makes the art. This kind of art ... is usually free from the dependence on the skill of the artist as a craftsman ... Most ideas that are successful are ludicrously simple ... To work with a plan that is pre-set is one way of avoiding subjectivity.[26]

In a new introduction to her 1973 book *Six Years: The Dematerialization of the Art Object*, the critic Lucy Lippard provided a useful definition of the Conceptualism that would come to dominate the art practice of the 1960s and 70s. In Conceptual art, she notes, 'the idea is paramount and the material form is secondary, lightweight, ephemeral, cheap, unpretentious and/or dematerialized.' She also neatly summarises the movement's aesthetic: 'For artists looking to restructure perception and the process/product relationship of art, information and systems replaced traditional formal concerns of composition, color, technique, and physical presence.'[27]

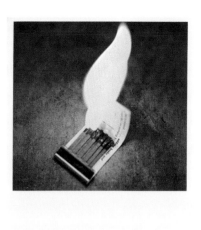

Page from VARIOUS SMALL FIRES
1964 [24]
Book
17.9 x 14 (7 1/16 x 5 1/2)

Ruscha's books were highly influential in the movement, and they do share many aspects of its practice: an 'idea' that dictates the form of the finished piece, an interest in structures, serial imagery and the mundane, working with 'information' (in his case the 'technical data' of his photographs), in art that takes place outside the walls of the gallery. He too was interested in the democratic principle of the artist making a cheap, mass-produced object for wide circulation. ('I want to get the price down, so everyone can afford one. I want to be the Henry Ford of book making.')[28] When the Library of Congress declined Ruscha's offer to donate a copy, the artist delightedly designed an advertisement in *Artforum* that read: 'REJECTED Oct. 2 1963 by the Library of Congress Washington 25, D.C., copies available @ $3.00.' He regrets numbering the first edition of *Twentysix Gasoline Stations*, since this raised its status from mass-produced object to collectible; subsequent books were unnumbered.

Yet Ruscha would be just as suspicious of the label of Conceptualism as he was of Pop; as he put it much later, 'I think anybody's [taken] out of Conceptual Art who makes any kind of image in his work, which I do.'[29] Despite the 'everyday' aesthetic of books like *Twentysix Gasoline Stations*, they have immense visual appeal. This is derived from the combination of the simplicity of the idea and its meticulous execution; the care taken in the selection of the subject matter and layout of the pages. Despite Ruscha's statements about the photographs being 'technical data', it's hard to ignore the romanticism of the distant, dead-end places that the gas stations evoke. Ruscha later said: 'I've often dreamt of living in a gas station. It's got the perfect layout – a roof to cut out the sun, pull your car under the roof, live inside.'[30]

The appeal of the book is highlighted in Ruscha's photographs *Hand Showing Book Cover* (fig.23) and *Hand Showing Book Spine* 1963, which document their aesthetic in the same way that Alfred Stieglitz famously captured the smooth lines of Duchamp's *Fountain*. A pair of hands carefully displays the little volume from different angles – in the first, from face on so that the title is legible, and in the second, flipped round to display the wording on the spine. Ruscha often showed a similar attention to detail by painting words on the edges of his canvases. These pictures serve to highlight the 'objectness' of the books, showing them as items to be used or handled, read, or in Duchamp's words, 'to be looked at'. Ruscha would draw, paint and photograph imagery from all his books, and also the books themselves, which indicates that he was not interested in the transient, in work that would decay or cease to exist, but in the tangible object.

Ruscha's second book, *Various Small Fires (and Milk)* 1964 (fig.24), was produced in a similar format to the first, sharing its sense of fun and incongruity. Here, he also followed the principle of settling on an 'idea' and going out to illustrate it. The fifteen 'small fires' of the title are domestic and harmless: a blowtorch, a flickering gas stove, a cigarette lighter, various smokers. The black-and-white photographs are all overprinted with a yellow varnish – with the exception of the concluding image, or 'huh?' moment, a glass of milk. The motifs of fire and the glass of milk would make their way into his paintings (see *Angry Because It's Plaster, Not Milk* 1965, p.58, and *Los Angeles County Museum on Fire* 1965–8, pp.62–3).

Testimony to the influential nature of Ruscha's book works is the fact that the artist Bruce Nauman used *Various Small Fires* for a book project of his own, *Burning Small Fires* 1968, a photographic series recording the burning of Ruscha's book page by page,

Spreads from SOME LOS ANGELES
APARTMENTS 1965 [25]
Book
18.1 x 14.3 (7 1/8 x 5 5/8)

which was then itself made into a limited-edition book. More recently, the artist Jonathan Monk further added to this commentary on the destruction of the art object by making a film installation in which he burns Ruscha's book with reference to Nauman's piece – *Small Fires Burning (after Ed Ruscha after Bruce Nauman after Ed Ruscha)* 2003. As well as being destroyed, Ruscha's books have also been much emulated – *Twentysix Abandoned Gasoline Stations* by Geoffrey Browse, produced in the same style and format, provided a nostalgic twist on Ruscha's original.

City
I developed a real closeness to the place. It has to do with the movies, it has to do with palm trees, it has to do with a collage in your mind of what this place is all about.[31]

Many of the photographs in Ruscha's books were taken from the streets within a short drive of his Hollywood studio. After several moves in the early 1960s, in 1965 he settled at 1024 N. Western Avenue, where he would remain for the next twenty years. Shortly afterwards, he made his third book, *Some Los Angeles Apartments* 1965 (fig.25), which presents in stark black and white a series of typical LA low- and high-rise apartment buildings, mainly examples of the architectural style of the 1950s and 60s. It now has the feel of a historical document, although this wasn't intentional. The Modern-style structures are of the sort described by Reyner Banham in his architectural study of Los Angeles as 'dingbats', plain boxes, ornamentally embellished: 'The front is a commercial pitch and a statement about the culture of individualism.'[32] In the book, Ruscha includes buildings displaying typography prominent enough to be visible from the road, such as the address text of *6565 Fountain Ave.* 1965. The bland boxes have exotic names in personalised typefaces. As in *Twentysix*

Gasoline Stations, the photographs are empty of human presence, simply containing the odd telegraph wire or palm tree bisecting the horizon line, and plenty of road in the foreground, and each building is rigorously labelled with its exact location.

From the apartment photographs, Ruscha created a series of ten delicate graphite drawings, abstracted with an exaggerated perspective, with details such as electrical wires eliminated and contours smoothed. In *Doheny Drive* 1965 (fig.26) the palm trees are silhouetted against the face of the building, and several storeys of balconies stretch from ground to sky like the stacked elements of a Donald Judd sculpture.

During the 1960s, Ruscha experimented with different methods of recording and presenting the city. Two works fulfilled his wish as a photographer to be as neutral as possible. For (*Every Building on*) *The Sunset Strip* 1966 (see Key Work, pp.44–7) he used a motorised camera to record a continuous length of the street; while the other books had involved the principle of selection, here he eliminated any element of choice and omitted nothing. If this book was a way of examining a single street in more depth, in his 1967 book *Thirtyfour Parking Lots* he chose the entire city, hiring a helicopter and a commercial photographer, Art Alanis. The pair flew over LA one Sunday morning to capture the city's lots as they lay vacant. The result was thirty-one dramatic aerial views (some with more than one parking lot, hence the 'thirtyfour' of the title), and the book is larger than the previous models ('I got the photographs back from the photographer and he'd made beautiful 8 x 10 glossy blowups … I couldn't bring myself to reduce those photographs to fit the original format.'[33])

Cars, in theory the organising principle of the book, are notable by their absence; as in Ruscha's unpeopled books, there are few vehicles in sight. It's hard to

DOHENY DRIVE 1965 [26]
Graphite on paper
35.9 × 57.5 (14 ⅛ × 22 ⅝)
Private collection

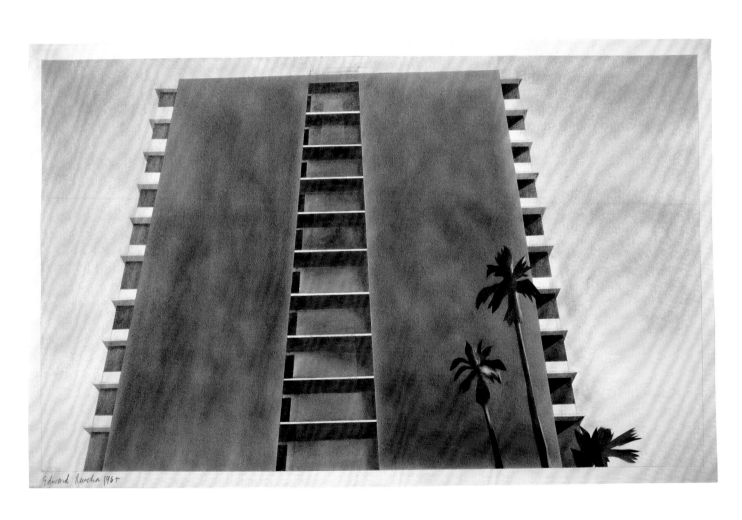

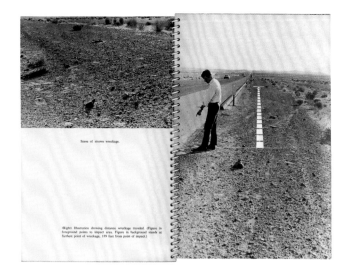

Cover and spread from
ROYAL ROAD TEST 1967 [27]
Book
24 x 16.5 (9 7/16 x 6 1/2)

imagine a city being so empty on a Sunday today. But this was in 1967, and in these pictures one is able to marvel over the patterned grids, which would be invisible from the ground. Myriad rings of parking spaces circle the massive 56,000-seater 'Dodgers Stadium, 1000 Elysian Park Ave.' (built five years earlier), and contrast with the regular grid of 'Good Year Tires, 6610 Laurel Canyon, North Hollywood' (fig.28). Like Dan Graham's photo-essay *Homes For America* 1966, the book made a visual link between the repetitive grids of the urban planners and the predominant features of Minimalist painting and sculpture. Ruscha expressed a different fascination, however: 'Those patterns and their abstract design quality mean nothing to me. I'll tell you what is more interesting: the oil droppings on the ground.'[34] His fascination with liquids will be discussed in Chapter 3.

In their use of the streets of Los Angeles as raw material, and their positioning outside the world of the museum, Ruscha's books can be compared with the 'happenings' that took place in the city during the 1960s.[35] Claes Oldenburg's *Autobodys* was a complex work of 'drive-in' theatre held in a rented parking lot on Beverly Boulevard in December 1963, where participants in their cars 'maneuvered across the rectangular lot; liquids such as milk, soapy water, and melting ice spilled across the asphalt; flashlights and flares lit up the night sky; and those observing heard the sounds of a radio, a loudspeaker, horns, car engines, the spinning drum of a concrete mixer and the breaking of glass'.[36] Allan Kaprow's installation *Fluids* 1967 placed primitive structures made from bricks of ice in a number of locations throughout the city, including car parks and disused spaces. Such pieces turned attention to these spaces in the same way that Ruscha's books ask us to look at the familiar in the city streets; his books can, in a sense, be seen as 'performances' in the city.

Ruscha's *Royal Road Test* 1967 (fig.27) is also reminiscent of performance pieces of the time. The story goes that the artist was driving back from Las Vegas along the desert freeway with friends Mason Williams and Patrick Blackwell, when Williams – who had been working on a novel – decided to throw Ruscha's Royal typewriter out of the window of his Buick Le Sabre. The trio ventured back to see the impact that the crash had caused, as if it were a crime scene; playing at cops, they took photographic 'evidence' of each individual part of the machine they found strewn across the dusty ground. All was documented in a small spiral-bound book, designed to look 'like a police report'.[37] It begins with a mock-poetic ode to the typewriter (in fact taken from an encyclopaedia definition of Dada): 'It was too directly bound to its own anguish to be anything other than a cry of negation; carrying with itself the seeds of its own destruction.' The facts are then wryly presented: 'Royal (Model "X" Typewriter)', 'Date: Sunday August 21, 1966. Time: 5.07 pm. Place: US Highway 91 (Interstate Highway 15) travelling South Southwest, approximately 122 miles Southwest of Las Vegas, Nevada. Weather: Perfect.' The individual dispersed elements of the broken machine are then documented: 'Piece of Cylinder Knob', 'Ribbon Spool and Ribbon', 'Tab Key Top (photographed as found in bush)'. The book ends with the shadows of the three men pointing to the wrecked body of the instrument on the ground. Other collaborative books made with artist friends that can be classed as 'capers' are *Business Cards* 1968, a photo-essay of a business-card exchange with Billy Al Bengston, and *Crackers* 1969, based on a story by Mason Williams and later made into the film *Premium* (see p.68). In another artistic car-based caper, Ruscha posed with eleven other Los Angeles artists in Joe Goode's *1969 Calendar. LA Artists in their Cars* 1969. He was the 'pin-up' for March.

THIRTYFOUR

PARKING

LOTS

Cover and spread from
THIRTYFOUR PARKING LOTS
1967 [28]
Book
25.4 x 20.3 (10 x 8)

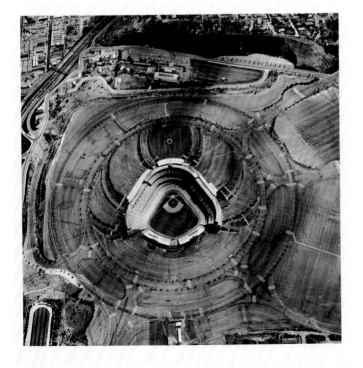

Dodgers Stadium, 1000 Elysian Park Ave.

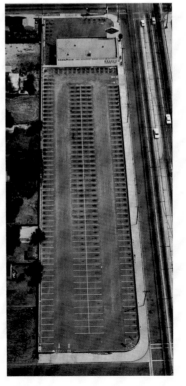

Good Year Tires, 6610 Laurel Canyon, North Hollywood

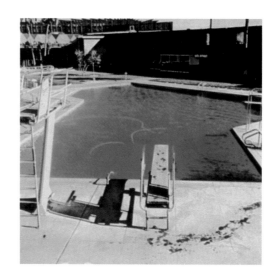

Cover and photograph from
NINE SWIMMING POOLS 1968 [29]
Book
18.1 x 14 (7 1/8 x 5 1/2)

REAL ESTATE OPPORTUNITIES [30]
Contact sheet for Ruscha's 1970 book
25.7 x 20.6 (10 1/8 x 8 1/8)
Whitney Museum of American Art,
New York

Ruscha introduced colour for his 1968 book *Nine Swimming Pools (and a Broken Glass)* (fig.29). The pool is an LA cliché, symbol of the luxurious and hedonistic Californian lifestyle, as in the works of David Hockney. The nine pools in Ruscha's book, from a selection of hotels in LA and Las Vegas, are deserted, and strangely haunting; they relate more to Mike Nichols' film *The Graduate* (1967), where the pool is a symbol of Benjamin Braddock's alienation, or to Billy Wilder's *Sunset Boulevard* (1950), which opens with B-movie hack Joe Gillis's Hollywood death:

Yes, this is Sunset Boulevard, Los Angeles, California ... A murder has been reported from one of those great big houses in the ten thousand block ... Nobody important, really. Just a movie writer with a couple of 'B' pictures to his credit. The poor dope! He always wanted a pool. Well, in the end he got himself a pool – only the price turned out to be a little high.

That Ruscha's pools are curiously interspersed throughout the book, often followed by a sequence of blank pages, adds to this impression – though Ruscha maintains that this device was dictated by the printer ('the cheapest way to have the color printed ... I could have added one or two more swimming pools at no extra cost, but I wanted the thing to be 'nine' swimming pools rather than 'eleven').[38] As with the oil spills of *Thirtyfour Parking Lots*, in *Pool No.6*, liquid footprints lead up to the diving board signifying the absent human subject. Did that person dive in and injure himself on the final image, a broken glass? This picture leaves a feeling of rupture after the pools – glass being the last thing you would want to find under your feet when going for a swim. Ruscha produced several drawings in relation to this book (see p.4).

Ruscha also put the 'personal' in to his books and photographic works: *Babycakes with Weights* 1970, a pastel blue book tied with a pink ribbon, contained a picture of his baby son, Edward Joseph Ruscha V, '15 lbs. 8 oz.', followed by snapshots of twenty-one mouthwatering cakes and desserts, with their respective weights. Ruscha Jr was born in 1968, following the artist's marriage to Danna Knego in Las Vegas in 1967. (They would divorce in 1976, and remarry in 1988.) Other personal inventories included photographic essays published in magazines: *Five 1955 Girlfriends* (1969) and *Five 1965 Girlfriends* (1970); and a 1971 book, *Records*, documenting highlights of his LP collection.

For *Real Estate Opportunities* 1970, Ruscha scouted the city, looking for vacant lots, at the same time taking reels of pictures of industrial buildings. He eventually selected twenty-five roadside shots, mostly marked out by commercial 'For Sale' signs (fig.30). The book has a strange aesthetic, since it appears to have almost no subject, the pictures characterised by scrubby, empty grassland, as if the town had been deserted. The post-war real-estate boom had by this point reached its peak, and the market had become oversaturated, leaving swathes of undesirable wasteland interspersed between housing and commercial developments. This desolate and hopeless appearance jars ironically with the 'opportunities' of the title. The suburban landscape was also changing dramatically, as huge tracts of Identikit homes were built out of town. Photographers began to document these developments: Californian Lewis Baltz's *Tract Houses* 1971, and Colorado resident Robert Adams's *The New West* 1968–74, and their precursor, Dan Graham's magazine piece *Homes for America* 1966, observed the social and environmental effect of the new homogenous or 'standardized' mass-housing.[39]

Ruscha might have followed this direction in his own photographs and books, but he has always avoided political or social comment in his work (and

MOCK UP #35 (NORTH WEST CORNER
OF CANYON DRIVE AND PARK WAY)
1971 [31]
23.8 x 17.1 (9 3/8 x 6 3/4)
Whitney Museum of American Art,
New York

A FEW PALM TREES 1971 [32]
Book
17.8 x 14 (7 x 5 1/2)

THE INFORMATION MAN [33]
Typewritten text

in his statements); instead, he continued to produce books using more positive symbols of the LA landscape as motifs. *A Few Palm Trees* 1971 and the incongruously titled *Colored People* 1972 both contained examples of palms and cacti in all shapes and sizes: tall, skinny, with huge fronds; in the former they are captioned with their exact street locations ('Island at Hollywood Blvd. & La Brea Ave.'; 'N.W. corner of Canon Dr. & Park Way', fig.32). The book begins with the information 'Camera facing west on all photos', 'in case people wanted to identify them'.[40] A contact sheet shows the neatly planted palm in context, complete with instructions to the printer for isolating the tree from its surroundings (fig.31).

In April 1972, all these books, along with prints and drawings, were included in a show at Minneapolis Institute of Arts. Ruscha designed a catalogue for the show that functioned as a mini guide to the artist. The tiny bright green volume is only a little larger than a cigarette packet. As well as reproductions of works, it includes an index of all the words used in his work to date, and ends with the photo essay *Tanks, Banks, Ranks, Thanks* – followed, appropriately, by an inch-thick of *blanks* (blank pages). Ruscha had now come to associate himself so firmly with Los Angeles that he used the motif of the palm tree on the front of the catalogue.

'The Information Man'

The Information Man, a typed text, penned after a 'daydream' (fig.33), can perhaps be seen as a meditation on the fact that Ruscha's book production had come to a natural conclusion. Its title may reference the 1970 exhibition *Information* at the Museum of Modern Art, a survey of Conceptual art, which included some of his books. This mock inventory of the whereabouts of all his books in circulation can – like his list-based books –

be read as an attempt to quantify the world around him; his is a world broken down into numbers and data, wryly categorised and neatly labelled. In a recent text, his brother Paul wrote: 'It is a known tale in our family that Eddie, as Ed was called as a boy, had a little cardboard box with Mickey Mouse on the top of it that was like one of those old-style, slide-out Rx-prescription boxes, and on the outside of it he had printed: "TEETH I HAVE LOST and MONEY I HAVE FOUND".'[41]

As a witty meditation on the afterlife of a work of art, *The Information Man* also proposes that art is not valuable; it exists to be enjoyed and used. As Claes Oldenburg put it in a 1961 text, 'I am for an art that is political-erotical-mystical, that does something other than sit on its ass in a museum.'[42] Ironically, rather than being used 'as swatters to kill small insects such as flies and mosquitos' or 'to transport foods like peanuts to a coffee table', as Ruscha speculates in *The Information Man*, the books have been widely exhibited in museums ever since, and, like the Conceptual art of the period, regularly fetch high prices at auction.

Ruscha's books shed much light on his paintings. As we have seen, there are themes and motifs common to both: the gasoline station, fires, food, Los Angeles houses, palms and streets; a fascination with mapping and numbers, change and decay; the attempt at a neutral and objective 'no-style' or 'readymade' aesthetic; a preference for the 'table-top' or aerial view, and for diagonal two-point perspective. Ultimately, in his books, as in his paintings, Ruscha enables us to look again at the familiar, detaching words or images from their surrounding sentences or settings so that they appear new. As J.G. Ballard wrote, 'Ruscha's images are mementos of the human race taken back with them by visitors from another planet.'[43]

October 2, 1971

It would be nice if sometime a man would come up
to me on the street and say "Hello, I'm the information
man and you have not said the word 'yours' for 13 min-
utes - you have not said the word 'praise' for 18 days,
3 hours and 9 minutes. You have not used the word
'petroleum' in your speech for almost four and a half
months, but you wrote the word last Friday evening at
9:35 pm and you used the word 'hello' about 30 seconds
ago."

This information man would also have details as to
the placement and whereabouts of things. He could tell
me possibly of all the books of mine that are out in the
public that only 17 are actually placed face up with
nothing covering them. 2,026 are in vertical positions
in libraries, while 2,715 are under books in stacks.
The most weight upon a single book is 68¾ pounds and
that is in the city of Cologne, Germany in a bookshop.
58 have been lost; 14 totally destroyed by water or
fire; while 216 could be considered badly worn. A whop-
ping 319 books are in positions between 40 and 50% and
most of these are probably in bookshelves with the stacks
leaning at odd angles. 18 of the books have been delib-
erately thrown away or purposely destroyed. A surprising
53 books have never been opened, most of these being newly
purchased and put aside momentarily. Of the approximate
5,000 books of Edward Ruscha that have been purchased,
only 32 have actually been used in a directly functional
manner: 13 of these have been used as weights for paper
or other things. 7 have been used as swatters to kill
small insects such as flies and mosquitoes and 2 have
been used in bodily self-defense. 10 have been used to
push open heavy doors (probably, since they are packaged
in 10s, one package was used to push open one door).
2 were used to nudge wall pictures into correct levels,
while one was used as a wiper to check the oil on an
auto dipstick. 3 are under pillows.

221 people have smelled the books' pages, probably
most of these on the original purchase.

3 of the books have been in continual motion since
their purchase over 2 years ago, all of these being on a
boat near Seattle, Washington.

Profanity used to discuss the books is as follows:
312 people have used profanity in criticizing them, while
435 people have used profanity in praising them. (This
last high figure probably due to the fact that profanity
is no longer used to necessarily condemn things.)

It would be nice to know these things.

In Oklahoma City I delivered newspapers riding along on my bicycle with my dog ... I dreamed about making a model of all the houses on that route, a tiny but detailed model that I could study like an architect standing over a table and plotting a city.[44]

The first pictures made of the Sunset Strip were taken by walking along the street. Only when I could see that it didn't produce results that I approved of – in other words, there were too many cars in the picture or it was the wrong time of day to photograph – did I decide I should maybe try something with a motorised camera.[45]

In 1966, Ruscha photographed the 'Strip' – the notorious stretch of Sunset Boulevard in West Hollywood – by attaching a motorised Nikon 250 camera to the back of his truck, shooting in real time while driving up and down the two-mile stretch. Using a mechanical device to take the photographs brought the objectivity he had been aiming for in earlier books. The length of the roll of film dictated the book's final form, a concertina that unfolded to a length of twenty-seven feet and revealed an exact model of both sides of the street, the sort he must have dreamed of as he delivered newspapers years before. The long paper roll folded into a shiny silver-coloured slipcase, perhaps a reference to the glittery excess of the area's nightlife (steeped in myth and legend, the Strip was a nexus of Hollywood parties and legendary venues like Whiskey A Go Go, the Chateau Marmont or Schwab's, where film and rock stars gathered to entertain themselves at all hours).

To create the book, the photographs were cut out by hand and pasted on to the layout, collaged without gaps or blanks in two, film-like ribbons, the north side of the street along the top (numbers 8024–9176), the south side underneath (9171–8101). The only thing disturbing the continuity of the scene are the cars, which – due to having driven past too quickly – are often chopped in half at the edges of the photographs. The flat, horizontal format is reminiscent of a Greek or Roman architectural frieze; it has no directional narrative, 'reading' both left to right, and right to left.

Indeed, the stark, factual display is rather like the presentation of evidence, the buildings resembling a line-up at a crime scene. There are no descriptive captions, only typed street numbers and the names of the road intersections. One searches for notable details on the buildings; the eye focuses, for instance, on the incomplete sign '*The ———*' at no.8844 on the north side – later the title of one of Ruscha's Mountain paintings.

In his previous books, Ruscha had used the principle of selection (*certain* gas stations, *various* apartments), but here he omits nothing. This attention to detail is similar to the agenda of French materialist writer Georges Perec (1936–82), who set himself exercises in the precise observation of the minutiae of his existence: the contents of his desk, the rooms of his apartment block, his neighbourhood in Paris, even his eating habits ('Attempt at an Inventory of the Liquid and Solid Foodstuffs Ingurgitated by Me in the Course of the Year Nineteen Hundred and Seventy-Four'). This extract from his text 'The Street' shows Perec's method, and seems to describe Ruscha's project perfectly:

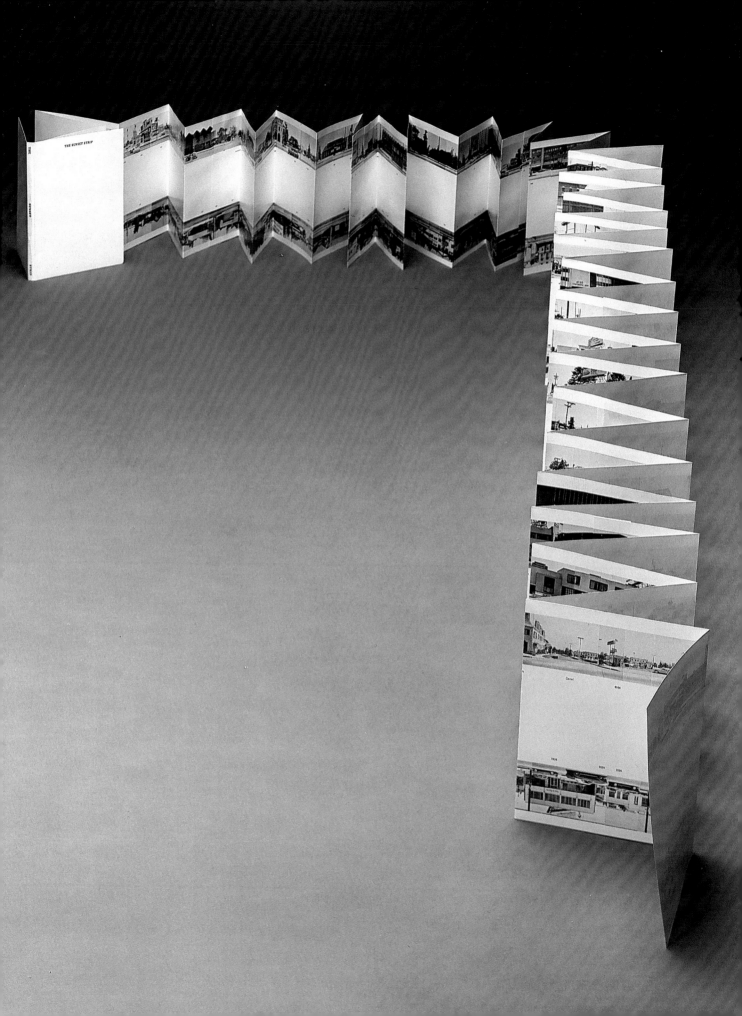

(EVERY BUILDING ON) THE SUNSET STRIP
1966 (detail) [34]
Book
17.8 x 14.3 x 760.7 (7 x 5 ⁵/₈ x 299 ¹/₂) (extended)

Observe the street, from time to time, with some concern for system perhaps.

Apply yourself. Take your time.

[...] Note down what you can see ... Is there anything that strikes you? ... Force yourself to write down what is of no interest, what is most obvious, most common, most colourless.[46]

Ruscha has said:

I'm looking at it [the Strip] almost like an anthropologist, or a geologist. I'm as interested in some of the less obvious things ... People look at the buildings and say, 'What was that building before?' Well, what about the sidewalk in front of it, and the curb that surrounds it, and embankments here and there? I'm trying to look at the whole picture.[47]

Ruscha's visual method of information-gathering and presentation was highly influential. Architect Robert Venturi, Denise Scott Brown, and Steven Izenour's seminal publication *Learning From Las Vegas* (1972), an investigation into the iconography of the new 'urban sprawl', photographed by different lensmen the Las Vegas Strip – which duplicated the clubs and bars of its namesake the Sunset Strip on a baroque scale – in a similar fashion.[48] The authors used Ruscha-like photographs as raw material to analyse 'the symbolism of architectural form', and noted the relationship between the buildings' form and their function: 'communication dominates space as an element in the architecture and in the landscape'; in this space, 'words and images are used for social persuasion'.

the driver has no time to ponder paradoxical subtleties with a dangerous, sinous maze. He or she

relies on signs for guidance – enormous signs in vast spaces at high speeds.

Service stations, motels, and other simpler types of buildings conform in general to this system of inflection toward the highway through the position and form of their elements. Regardless of the front, the back of the building is styleless, because no-one sees the back.[49]

This can be compared with Ruscha's musing on the Sunset Strip, in which he likens the street to a two-dimensional film set:

Los Angeles to me is like a series of store-front planes that are all vertical from the street, and there's almost like nothing behind the facades. It's all facades here – that's what intrigues me about the whole city of Los Angeles ... Streets are like ribbons. They're like ribbons and they're dotted with facts. Fact ribbons, I guess.[50]

Ruscha continues to document the Strip, and other Los Angeles locations such as Hollywood Boulevard, in photographic form (see *Then and Now*, p.99). In the 1990s, he also remade a portfolio of images from *(Every Building on) The Sunset Strip* as a photographic edition (p.94).

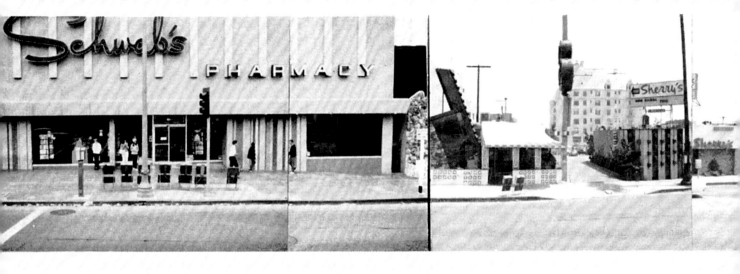

8024 Sunset 8100 8106

Laurel Canyon 8101 s.

ANNIE, POURED FROM MAPLE
SYRUP 1966 [35]
Oil on canvas
139.7 x 149.9 (55 x 59)
Norton Simon Museum,
Pasadena, California

Notebook showing 'studies of
syrup formations', 10 April 1966 [36]

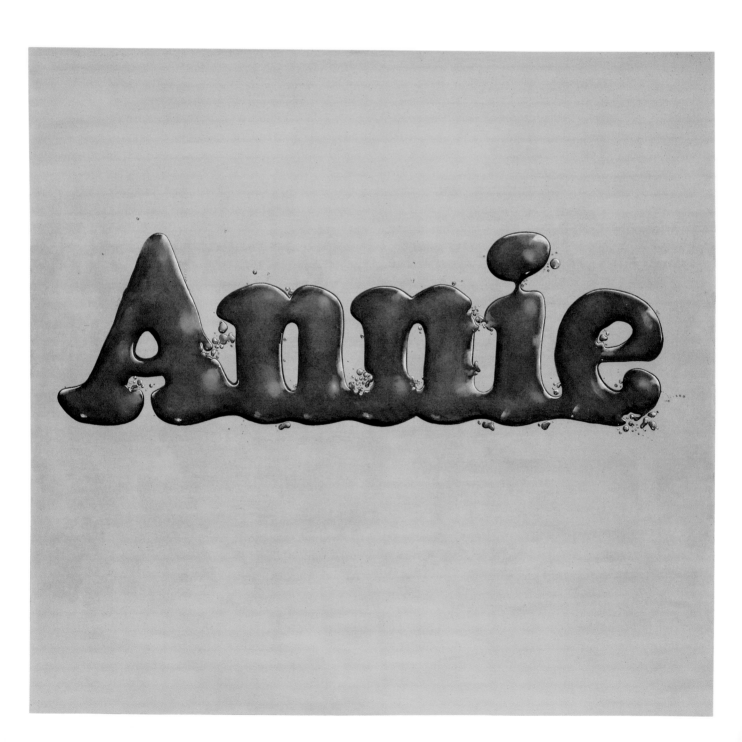

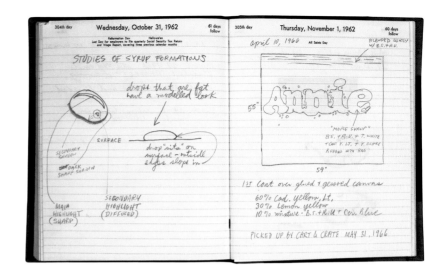

3

I don't know why it happened, but close-up views of liquids somehow began to interest me. And then I started making little setups on tables, and painting them, using syrup, and studying what happens when you pour syrup out, or turpentine, or water. [51]

Words had appeared in Ruscha's paintings as early as 1959, but in the late 1960s, their constituent characters began to change shape. Gone was the flat Pop typography; text now morphed into more fluid forms, creating the illusion of the lettering oozing or spilling out onto the canvas. Ruscha has dubbed this phase his 'romance with liquids' period (the phrase was later the title of a 1975 drawing and an exhibition title). He said: 'I was looking for some sort of alternative entertainment for myself – an alternative from the rigid, hard-edged painting of words that had to respect some typographical design. They didn't – there were no rules about how a letter had to be formed.'[52] A notebook from 1966, seen here opened at a page headed 'studies of syrup formations' (fig.36), shows the artist experimenting with drawing globular shapes, imagining in sketch form how drops of a syrupy substance would 'sit' on the surface of the canvas, and working out how best to place the shadows and highlights. In *Annie, Poured from Maple Syrup* 1966 (fig.35) the illusion is complete: the treacley goo of the title appears to float above the yellow ground, and the bubbly characters merge into each other as if they really had been 'poured'. The idea of sugary syrup complements the saccharine feel of the 'Little Orphan Annie' cartoon-strip, from which the design was taken.

Words as Objects

Works of art have long featured words, either on the periphery (fragments of newspaper in Cubist works or Dada collages) or as the main event (the lettering of branded products writ large in Pop, or text as substitute for images in Conceptual art). Few artists have used words as consistently and with as much delight as Ruscha, for whom they almost seem to replace the traditional life-model or muse. His appreciation of typography and his interest in language – fuelled by his training as a graphic designer – is manifest in his disposition towards playful word games (calligrams, palindromes) and his interest in the sounds of words, including a variety of vernacular speech and dialogue, and impediments such as lisping or stuttering. Ruscha's word works revel in the fact that a word exists materially, with object form, or acoustically, as a sound made in the mouth and received by the ear. His words also appear to have tactility, taste and smell. 'Words have temperatures to me', he has said. 'When they reach a certain point and become hot words, then they appeal to me … Sometimes I have a dream that if a word gets too hot and too appealing it will boil apart, and I won't be able to read or think of it. Usually, I catch them before they get too hot.'[53]

In the light of this remark, Ruscha's word paintings of the 1960s begin to look like literal examples of the neurological condition synaesthesia, where words or letters may simultaneously evoke combinations of colours, shapes, tastes, sounds or temperatures. Synaesthesia can be permanent or temporary; for example, it can be experienced under the influence of psychedelic drugs. Many poets, artists and musicians have this condition, including Franz Liszt, Wassily Kandinsky and Vladimir Nabokov; for the latter, specific hues are evoked by individually sounded letters. He describes the specifics of these colour-sound relations in his autobiography *Speak, Memory* with Ruscha-like detachment: 'In the green group, there are alder-leaf f, the unripe apple of p, and pistachio t. Dull green, combined with violet, is the best I can do for w. The yellows comprise various e's

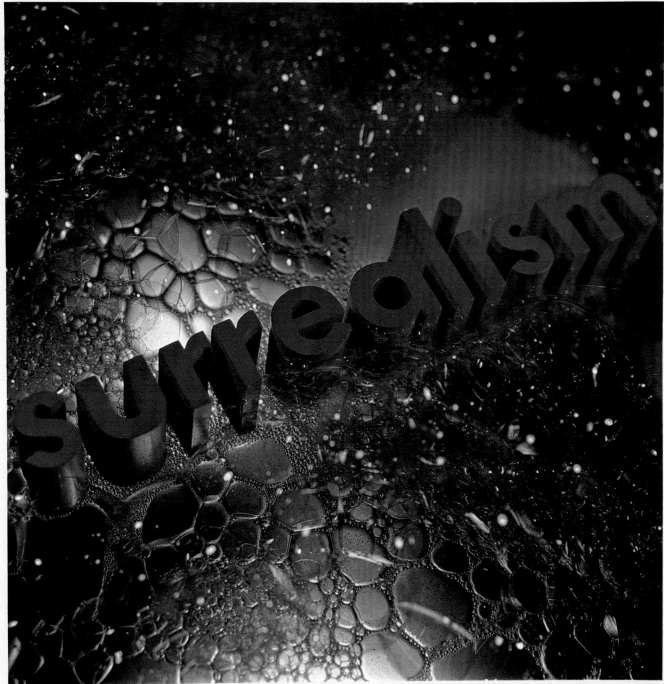

2/1,004

E. Ruscha 1966

SURREALISM, SOAPED AND
SCRUBBED 1966 [37]
Chromogenic print
27.9 x 35.6 (11 x 14)

SQUEEZING DIMPLE 1964 [38]
Oil on linen
71.8 x 75.9 (28 1/4 x 29 7/8)
Private collection

and i's, creamy d, bright-golden y, and u whose alphabetical value I can express only by 'brassy with an olive sheen'.[54] Similarly, Arthur Rimbaud's 1871 poem *Voyelles* ('Vowels') describes the hues and associations of different vowel sounds. Whether or not Ruscha's 'hot' words constitute a form of synaesthesia, it is clear from his works that his appreciation and enjoyment of words is at least partly due to their capacity to trigger other senses.

In 1965, Ruscha began working as a layout artist for the journal *Artforum*. That year, the founding editors, writer Philip Leider and photographer John Coplans, had relocated from San Francisco, taking offices directly above Ferus Gallery on La Cienega. (Ruscha continued designing under the pseudonym 'Eddie Russia' until 1969, two years after the magazine's relocation to New York.) *Artforum* was already influential, and its regular writers, including Michael Fried and Rosalind Krauss, would become some of the art world's most prominent critics. Particular issues are now legendary, and one of these is 'Surrealism' of September 1966, for which Ruscha designed an intricate photographic cover (*Surrealism, Soaped and Scrubbed*, fig.37). This multi-layered work was achieved by setting up carved wooden lettering on a glass table, covering them with soap bubbles, and lighting them with coloured bulbs from below.

As with so many of Ruscha's works, the photograph highlights the importance of the *objectness* of words, as real things that exist in real space. It followed works such as *Squeezing Dimple* 1964 (fig.38) – where four painted metal clamps contort the shape of the letter 'd' – and *Securing the Last Letter* 1964, where the 's' of the word 'Boss' is pinched in the same way. Other strategies involving verbal violence include a painting of the word 'Damage' set on fire, and *Hurting the Word Radio*. These visual *double entendres* playfully point

up the words' existence as both conveyors of meaning and as objects with a solid form. ('I see words as objects', Ruscha later said. 'I am painting pictures of objects. Giorgio Morandi ... painted endless still lifes of bottles. I paint objects too but mine are words.')[55] The same year in which Ruscha made *Surrealism Soaped and Scrubbed*, Bruce Nauman made the punning works *Waxing Hot* and *Eating My Words* 1966, where the titles are enacted in photographic form.

Following *Annie, Poured from Maple Syrup* and his *Surrealism* table set-up, Ruscha began painting 'object' words with trompe l'oeil lettering that appears to have been 'spilled' on to the canvas. Rather than a permeable skin that will absorb marks, the surface of the canvas here appears to repel these melting, Dalíesque letters, like the bonnet of a car or a sheet of plastic. And one has the feeling of looking down on the paintings from above. In an important essay, 'Thermometers Should Last Forever',[56] Yve-Alain Bois notes that in this orientation these works are 'engaged in a dialogue with Pollock's drip paintings'. Ruscha's works are about spillages or drips on canvas, in true Abstract Expressionist fashion, yet in keeping with his notion of the premeditated image there is no spontaneity (each is planned meticulously in advance) and they have a pristine feel. There is a contradiction 'between the messiness of the depicted spill and the "professional finish" of the trompe l'oeil rendition' and 'that between the gravity-free ground and the letters spilled from above'.[57] Like Warhol's Oxidation or 'piss paintings', might they also mock the macho ejaculations of the Abstract Expressionists? *Desire* 1969, lettered in a white liquid that could be semen, would suggest so.

Though these works are involved in the dialogue between the 'handmade' gesture of Abstract Expressionism versus the 'readymade' mark of Pop,

LISP 1968 [39]
Oil on canvas
50.8 x 61 (20 x 24)
Nora Eccles Harrison Museum
of Art, Logan, Utah

ADIOS 1967 [40]
Oil on canvas
151.1 x 137.5 (59 ½ x 54 ⅛)
Private collection, Chicago

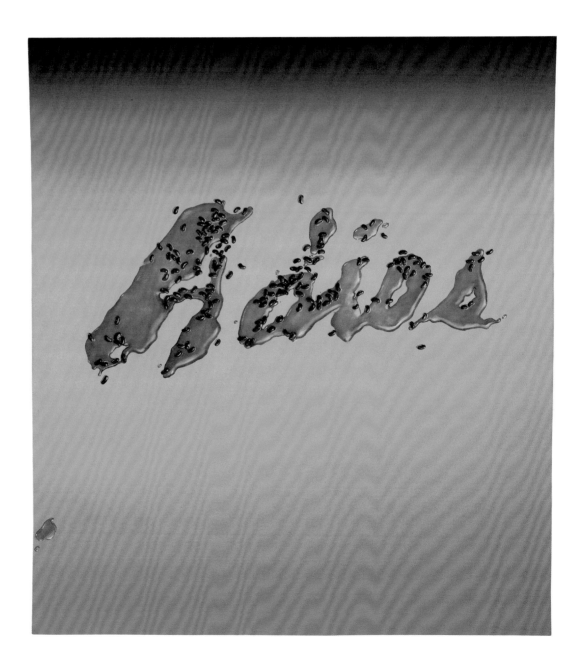

E. Ruscha 1967

E. Ruscha 1968

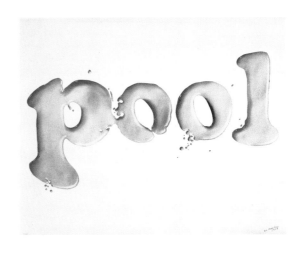

LISP (#2 – WITH WATER DROPS)
1967 [41]
Powdered graphite and
pencil on paper
33.7 × 54.5 (13 1/4 × 21 7/16)
Private collection

OKLA. 1968 [42]
Gunpowder on paper
33.7 × 54.5 (13 1/4 × 21 7/16)
Private collection

POOL 1968 [43]
Gunpowder on paper
58.4 × 73.7 (23 × 29)
Philadelphia Museum of Art

they can also be seen to relate to the Concrete Poem or calligram, a text in which the meaning is echoed or extended by the typographical configuration of the word or words in space. Though they were not the first to do so, Mallarmé and Apollinaire shared an interest in such a play with words, and in the 1960s, artists such as Carl Andre and Robert Smithson also made works in this vein. For example, Smithson's *A Heap of Language* 1966 is literally that – a long list of handwritten words, all of them relating to language ('dialect', 'mother-tongue', 'Esperanto', 'Babel', and so on), fashioned into the shape of a mountain.

In Ruscha's word works of the 1960s, the depiction of the chosen word sometimes seems analogous to its meaning and other times seems irrelevant. In the canvas *Lisp* 1968 (fig.39) a word formed from a puddle of water is punctuated by globules of spittle (of the sort that would land on the canvas if the word were pronounced by someone with a lisp). The painting *Ripe* 1968 also makes perfect sense, since the word of the title is composed of a fleshy-red jelly oozing what appear to be pomegranate seeds. Other works in this series also refer to liquid or organic substances (*Jelly, Slug, Ripe, Mint, Oily*) and often contain tiny beans or seeds. But what of *City* 1968, a word also formed of liquid, whose first letter seems to resemble an 'O' or the sort of ring a glass of water would leave on a table? Or the intricately painted *Adios* 1967 (fig.40), an apparently sticky or oily substance peppered with tiny 'spilled' beans. We are left to form our own conclusions about these. Perhaps the 'O' in *City* stands for Oklahoma City, Ruscha's hometown; maybe the combination of 'jumping' beans and the Spanish word for 'goodbye' in *Adios* relate to Latino culture. Works such as these, where words are turned into brands or logos, also seem at home in the world of advertising and commercial design.

As well as the liquid letters, Ruscha also created intricate drawings of words that seem to be formed of rolls of paper or card, curled, folded or cut into lowercase or capital letters. Ruscha has said that he initially tried to make actual models for these using paper, but achieved better results by working directly from his imagination. Like his liquid letters, the playful, self-referential text ribbons of works such as *Strip* or *Film* 1967 abandon conventional typography and point up the material form of the words depicted. They are reminiscent of reels of film or rolls of toilet paper, of the horizontality of the street, in particular the accordion-fold format of his book *(Every Building on) The Sunset Strip* (see p.45), or of brand lettering like the spaghetti script of Coca-Cola or Dr Pepper.

Many of the drawings are architectural in feel. OKLA. (fig.42), depicted as if viewed from the air, appears 'built up' from paper letters that could be high-rise apartment blocks, in reference to the fact that the 'Okla.' of the title is the state of Oklahoma. The text of this work may also be read as a fusion of 'OK' (for Okay, or Oklahoma) with 'LA' (for Los Angeles). As we have seen, Ruscha had always favoured the aerial or tabletop view, and in 1965 he began a major painting of the new Los Angeles County Museum of Art from this perspective (see pp.62–3). The city from above would also be the theme of his 1967 book *Thirtyfour Parking Lots* and later, his series of themed works called City Lights and Metro Plots (see pp.83, 101).

At this time, Ruscha began to mix the unusual medium of gunpowder with the graphite or pastel he was using for these drawings (for a description of this technique, see p.75). The substance he created was 'drier and more powdery' than graphite, and flexible in that he could easily correct mistakes and build up shadows and contours by applying layers of gunpowder and fixative. Ruscha's 'cut-paper' gunpowder words

would lead to studies of the Hollywood sign (p.114), fashioned from similar letters, and would continue to preoccupy him into the 1970s.

Other word works of this time were also composed of simple 'no-style' lettering. In the painting *Chemical* 1966 (fig.44), dark capital letters are stretched out across the width of the canvas, which in this case is painted a pea-soupy yellow, perhaps representing a smoggy, druggy haze. This is one of the most literal examples of the idea of words breaking apart until they lose their meaning – what's left is just the material or object form of the words, the simple shapes of the letters. We are left to pronounce them aloud or observe the patterns created by the letters. Robert Smithson wrote, 'Look at any *word* long enough and you will see it open up into a series of faults, into a terrain of particles.' Ruscha shares this objectivity:

Isn't it curious that those little squiggles – the way they come about, and the way they form and follow one another and precede one another – go to make up that funny word? If you isolate a word for just a moment and repeat it ten, fifteen times, you can easily drive the meaning from the word … I find it curious that I've never wanted to misspell a word.[58]

Objects in Space

In contrast to the flat grounds of Pop works like OOF (p.21), a dreamscape background made of blended colours would become a feature of Ruscha's work from the 1960s onwards. In works on canvas he painted this space 'robotically', layering fine, horizontal brushstrokes to create subtle gradations of colour, usually becoming darker towards the upper edge of the canvas; in works on paper, fine layers of pastel or graphite were blended on the surface using cotton puffs to form a similar effect ('I've always believed in anonymity as far as a backdrop goes').[59] He had stumbled upon the idea of a blended ground while working on a screenprint, *Standard Station* 1966, which used a 'split fountain' silkscreen technique to mix two inks directly on the press. The critic Dave Hickey has compared the effect to the air of Los Angeles ('L.A. Space, its horizonless murk. Cropped off on the inland side by the crisp silhouette of mountains and dissolving in all other directions into the Pacific, it had no middle distance. There was only a gritty, fly-specked *near* and a hazy, enigmatic *far*.'[60]) Rosalind Krauss has linked Ruscha's grounds to those of the Surrealist Yves Tanguy, although, she notes, Ruscha's hues have the feeling of a commercial colour chart.[61]

Ruscha has frequently been compared to the Surrealists and Dadaists due to his use of deadpan wit, and interest in the incongruous. In the late 1960s, these movements were the popular subjects of art exhibitions in the city – Duchamp at Pasadena, Cornell and Schwitters at Ferus as well as the survey *Dada, Surrealism and their Heritage* at LACMA. Perhaps even more significantly, the Surrealist 'look' could equally be found in the counterculture, where escape from rationality through the use of psychedelic drugs was encouraged. Ruscha's dreamscape spaces and 'hot' words should be seen not only in relation to Surrealism, but also in the light of the music of West Coast musicians Captain Beefheart or Frank Zappa and the dream logic of films like *Easy Rider* and *Head*, both made in 1969.

Unlike Surrealists such as Tanguy, who floated abstract shapes in the dream-space of his canvases, Ruscha foregrounded ordinary everyday objects such as could be found lying around in the studio – a glass of milk, gasoline, water or soap bubbles, pencils, ball bearings, marbles, bowling balls, apples, pills (*Bowling Ball, Olive* 1969; *Pencil, Olive, Amphetamine* 1969), all painted 'actual size' as in the canvas *Noise, Pencil,*

CHEMICAL 1966 [44]
Oil on canvas
51.1 x 61.3 (20 $\frac{1}{8}$ x 24 $\frac{1}{8}$)
Private collection

ANGRY BECAUSE IT'S PLASTER,
NOT MILK 1965 [45]
Oil on canvas
139.7 x 121.9 (55 x 48)
Private collection

JAR OF OLIVES, FALLING 1969 [46]
Oil on canvas
152.4 x 137.2 (60 x 54)
The Modern Art Museum,
Fort Worth

Broken Pencil, Cheap Western 1963 (p.29). Such commonplace objects are endlessly recycled in Ruscha's paintings, drawings, prints and books; they are often depicted in motion or in the process of transformation – breaking, bouncing, floating, spilling, shattering or smashing. In combination, Ruscha's works of this period seem like the production of a dream – or hallucination. This they do share with Surrealists like René Magritte, who also painted endless variations of repeated subjects – cloudy skies, figures wearing bowler hats, apples, windows, to name a few. While Magritte's imagery is symbolic, however, suggesting the power of dreams to unlock hidden fantasies, Ruscha's depicted items are notable not for their symbolism, but for the way in which they function as 'readymades', actual objects divorced from their surroundings and presented on the canvas, just like his suspended words that are extracted from sentences.

Ruscha had engaged with more traditional Surrealist imagery in a series of paintings and drawings featuring anthropomorphised birds, fish and inanimate objects, playfully juxtaposed in a hallucinatory fashion. Pencils, symbols of artistic invention, morph into birds' feathers, beaks, fish-hooks, worms and even the hands of the artist (one drawing recalls the 'Drawing Hands' of M.C. Escher). *Angry Because It's Plaster, Not Milk* 1965 (fig.45), shown at his third solo exhibition at Ferus in November 1965, presents a bizarre scenario in which a clumsy bird appears to have knocked over a glass of milk. The bird is cross, we are told, because it's actually plaster. In truth, it is neither plaster nor milk, but paint. This double meaning relates the picture to works such as Magritte's *The Treachery of Images* 1929. Taken literally, this painting – a picture of a pipe, captioned 'Ceci n'est pas une pipe' ('This is not a pipe') – appears to be a contradiction.

But, on another level, the image is certainly not a pipe, but a reproduction or representation of one.

A common theme for Ruscha is transformation and self-referentiality, most clearly manifested in works where one 'series' morphs into another. In the Los Angeles apartment drawing *Barrington Ave.* 1965 the right side of the flat-fronted building morphs into a sheet of paper, a precursor of a 'curled paper' drawing like *Lisp* (fig.41). The gunpowder, graphite and watercolour drawing *Nine Swimming Pools* 1972 (p.4), merges the image of Ruscha's 1968 book with his 'liquid' words; floating in space, its pages open to reveal a watery blue 'pool' inside. He would also play with absurd juxtapositions in photographic form (*Sweets, Meats, Sheets* 1975, p.67) and canvases, such as *The World and its Onions* 1980, where a tiny globe floats in the sky surrounded by spring onions.

Ruscha's robotically prepared backgrounds, completed before the foreground is decided, form the basis for an important aspect of his art – working in series. Like a 'riffing' jazz musician, he would embellish these fields of colour with interchangeable words or objects that provide character in the foreground. Both the grounds and the objects in front would evolve over the years. The liquid letters and paintings of food would lead to work with real materials during the next decade.

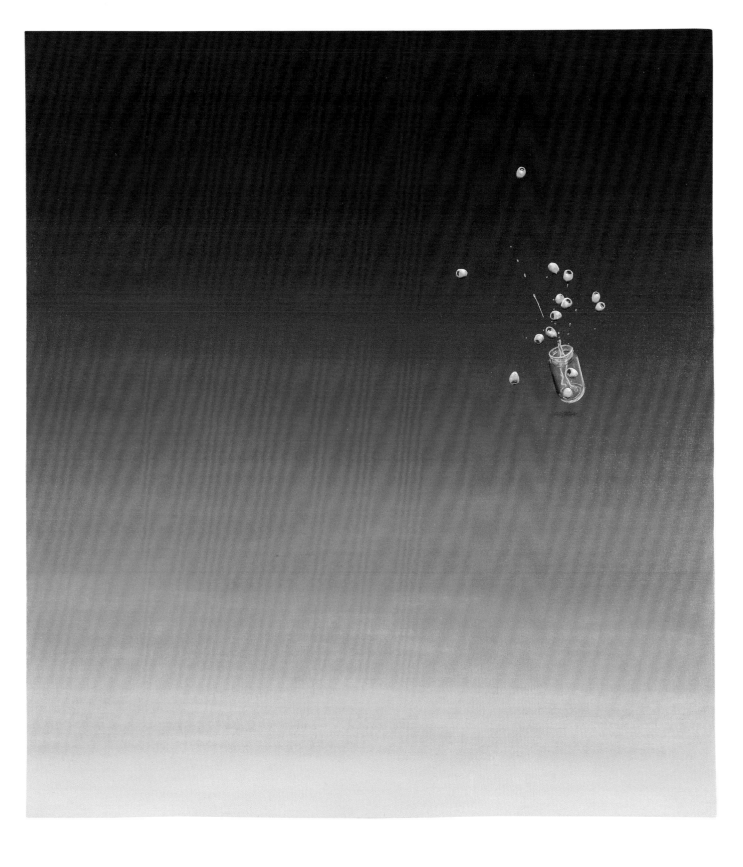

The opening of the new Los Angeles County Museum of Art in 1964 was a huge event in the city's art scene. Ruscha began *Los Angeles County Museum on Fire* in 1965, after taking some photographs while flying over in a helicopter. On the ground, he also shot various details of the Museum's three huge pavilions and forecourt (designed in the Modern style by William Pereira and Associates). The painting had a long genesis: 'I would put it away and cover it up and not paint on it for a year, and then I would go back to it and peck on it.'[62]

The picture was unveiled at a solo show at the Irving Blum gallery in LA on 30 January 1968. 'Los Angeles Fire Marshall says he will attend', said a telegram press release, 'see the most controversial painting to be shown in Los Angeles in our time'. To generate a sense of awe, the picture was cordoned off by a rope. At eleven feet wide, it has an air of unreality. The museum hovers in a dream-like space in a similar way to Ruscha's floating words and objects. The peculiar aerial perspective and the clean lines of the building's exterior create the impression that it has been drawn from an architectural model. The box-shaped pavilions look pristine, and Ruscha's cinematic perspective accentuates their geometric shapes and sharp angles. Rows of neatly planted trees and street lamps are arranged in the courtyard, though there are no visitors to enjoy them. The surrounding reflecting pools have a mirror-like sheen, and its dark colour contrasts with an acid yellow and brown sky, painted smoothly in the same 'industrial' style as the backgrounds of earlier word paintings (such as *Chemical*, p.57). Disturbing the order of the scene, in the building on the far left, black smoke and billowing flames are beginning to rage. The colours of the background and the smoky flames create a sinister feel, though Ruscha always describes this work as a calm painting. He stated in a 1972 interview with David Bourdon:

I had gone over the art museum in a helicopter . . . and took a lot of pictures of it. Also, there was an aerial photograph of the museum on the cover of the telephone book; it was really a nice picture, with a beautiful background to it, so that kind of moved me in that direction too.

I knew at the time that I started the picture that I was going to assault that building somehow. It wasn't the idea of it being an art museum, because there were several other buildings I could have worked on.[63]

He has recently commented on the compositional elements and themes (fire, aerial perspective) that the painting shares with other works:

The museum painting grew out of this landscape architectural idea that things go from the lower right-hand side of the canvas to the upper left-hand side of the canvas; it follows

that line of thinking, but in a different way: from an aerial perspective. Who knows how fire ever came into my life as an artist, but it's not a hot issue to me. No pun intended! Fire has no edges or forms – there's an action to a fire but it can take any shape. It's something that can just go wild and form in any way it wants to. Most of the time, I've used it as a secondary issue; it's off to the side of the painting, almost like it's ready to leave the painting.[64]

The 'small fire' in the painting has been variously interpreted. It could be an anti-establishment gesture (an assault on the museum system) or a reference to the burgeoning LA art scene, which was indeed 'on fire' at this time. It could be an allusion to 'noir' Los Angeles, town of the apocalyptic fiction of Nathaniel West, and the seedy underbelly described by Raymond Chandler or James Ellroy. Or it might recall the burning of the city during the Watts race riots of August 1965, or its natural disasters, forest fires, floods, earthquakes (see Malcolm Morley's *Los Angeles Yellow Pages* 1971, the 'stack' freeway intersection, split down the middle by a deep fault line).

Ruscha provides a more surprising reading of the painting:

The art museum is an authority figure, and destroying that authority figure might be a step in the right direction. But the painting had other undersides to it. Every time I went to London, to the Tate, I would see [John Everett Millais's] Ophelia, *and somehow I based it on that.* Ophelia *is an oblique, aerial view, and it has a very quiet, serene surrounding to it. So that painting of mine is my* Ophelia. *And I think that's probably where it emerged from.*[65]

An equally plausible source in the Tate's collection would be J.M.W. Turner's *The Burning of the Houses of Lords and Commons* 1834, also an assault on authority, since it depicts the buildings of the Houses Parliament going up in smoke. Ruscha has also said:

Although I didn't have any particular gripe against the LA County Museum, I do have a basic suspicion of art institutions, period ... But I actually feel like there's something classical and gentle about that painting. There's this nice green lawn around the building and everything's so peaceful – and suddenly there's this little flame over there on the side that looks as if it could possibly engulf the whole building. But the fire is really like an after-statement – like a coda, as in a coda to music, which is something I find myself doing a lot in my work.[66]

LOS ANGELES COUNTY MUSEUM ON FIRE
1965–8 [47]
Oil on canvas
135.9 × 339.1 (53 ½ × 133 ½)
Hirshhorn Museum and Sculpture Garden,
Smithsonian Institution, Washington, D.C.

Front cover and Worcestershire
Sauce stain from STAINS 1969 [48]
Book of 75 mixed media stains on
paper plus one stain on white
silk-moiré fabric, boxed in portfolio
30.5 x 27.9 (12 x 11)

69

Ruscha gathering ingredients for the portfolio *News, Mews, Pews, Brews, Stews & Dues*
London 1970 [49]

'SAND IN THE VASELINE'
RUSCHA'S MATERIALS

4

Ruscha's love for the physical process of working with tactile materials can be traced back to his childhood fascination with the tools of the artist's trade, the smells and textures of India ink, turpentine and linseed oil, and the canvas bag and inky paper of his newspaper delivery route. As discussed in the previous chapters, food and liquids – along with words – have been common motifs in his works, from the 'squashed' raisin carton of *Box Smashed Flat*, to 'spills' (*Ripe*) and the suspension of objects in space (*Jar of Olives, Falling*, p.59).

Ruscha's print portfolio *Stains* 1969 (fig.48) marked a transition from the depiction of illusionistic liquids to experimentation with actual substances; this tendency would preoccupy him in the prints, drawings and paintings of the 1970s. The seventy-five 'stains' included in this portfolio were dropped at random on to individual sheets of white paper with an eyedropper. An inventory of these is documented on the title page, from *1. Los Angeles Tap Water* to *75. Cinnamon Oil (Magnus, Mabee & Reynard)*. The stains fall into the categories of organic: 'Grass', 'Cabbage (Red)', 'Egg yolk'; ingestible branded foods or liquids, such as those found in a supermarket: 'Beer (Coors)', 'Salad Dressing (Kraft Roka blue cheese)', 'Chocolate Syrup (Hershey's)'; and non-edible substances that one might expect to find around the studio: 'Turpentine (T&R Factors of Texas)', 'Ammonia (Goodwin's)', 'Bleach (Clorox)'. Many of the substances or images that Ruscha would use in his work appear in this list; as such, it reads as an index of his interests: '13. Ant', '14. Gunpowder (DuPont Superfine)', '39. Milk (Knudson)', '54. Spinach', '70. Olive Oil (Star)' and '72. Motor Oil (Texaco 30W-HD)'. The meticulousness with which he parenthesises the exact brand echoes the precision with which he labels the locations of gas stations, streets and apartment buildings in his books.

The 'stains' were boxed together in a sumptuous black case with the title scripted in a gothic font with silver ink. Inside the portfolio's silk-moiré lining was one final stain: the blood of the artist, conjuring up the image of a shroud. Ruscha once said of the work: 'It is a shallow box of black needle-finished leather. It has a Church look and quality about it … a kind of coffin!'[67] In the same way that Ruscha 'stamped' these boxes with his own blood, Marcel Duchamp had 'authored' his own index of his work, the leather suitcase *Boîte-en-valise*, by including a painting entitled *Wayward Landscape* 1942 that had been made with his own semen.

On a trip to London in 1970, Ruscha made another print portfolio *News, Mews, Pews, Brews, Stews and Dues* at Editions Alecto (fig.50). Like *Stains* and his drawings using gunpowder mixed with charcoal (see p.75), the project involved working with unusual materials. This time, however, they were used in place of conventional printing inks. Ruscha spent time deriving colours from unlikely – and poetic – combinations. In a 1970 interview, he described the 'juggling act' of testing out substances, with varying degrees of success: 'Carnations did not pull. The paste separated from the liquid … certain brands of mustard turned to dust, and chicory syrup similarly … It's very difficult to look at colors and guess what they will turn out like. Tomato paste, for example, dries to gray dust.'[68] The works in the series were eventually created from equally bizarre mixtures: *News* (blackcurrant preserves mixed with salmon roe), *Mews* (egg and pasta sauce), *Pews* (chocolate syrup, coffee, squid ink), *Stews* (baked beans blended with daffodils, chutney, tulips, caviar and cherry-pie filling), *Dues* (pickle). In the end, he said, he was most pleased with *Brews*: 'The pleasure of it is both in the wit and the absurdity of the combination. I mean, the idea of

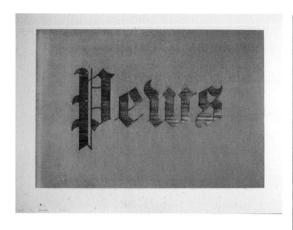

PEWS from the series *News, Mews,*
Pews, Brews, Stews & Dues 1970 [50]
Organic screenprint
58.4 x 78.7 (23 x 31)

CHOCOLATE ROOM 1970/2004 [51]
Chocolate on paper
Dimensions variable
Installed at the Museum of
Contemporary Art, Los Angeles

combining axle grease and caviar!'.[69] In fact, the inventory of materials is rather more 'colourful' than the prints, which look quite pale considering the technicolour promise of their beginnings.

Of the title, Ruscha has said: 'I was intent on invoking symbols of Great Britain: News = England being a tabloid-minded country. Mews = little alley streets. Pews = Westminster Abbey, Church of England. Brews = stouts, ales, bitters. Stews = local cuisine. Dues = Robin Hood, unfair taxation.'[70] To complement the Old English feel, the words were written in a Gothic typeface, and the prints – like the crown jewels – were cased in a red velvet portfolio box. Ruscha would later create other works using rhyming title schemes: *Tanks, Banks, Ranks, Thanks* 1971, a photo essay following the format of his artists books designed for the San Francisco magazine *Rags*, and the photographic screenprint *Sweets, Meats, Sheets* (fig.52) from the 1975 *Tropical Fish Series*. The latter presents the unlikely combination of packages of Hershey's Kisses, cuts of red meat and white bedsheets floating in the air above a red satin backdrop. The fact that the sounds of the words are prioritised over their meaning is typical of Ruscha's playful use of language. ('I liked the idea that rhyming words would present us with a set of clashing subjects and imagery.'[71])

During the 1970s, Ruscha began showing work more regularly in Europe as well as in the United States. Following his first solo show in Europe, at Galerie Rudolf Zwirner in Cologne in 1968, he would exhibit his 'liquid' word paintings at Alexander Iolas in Paris (1970) and his books at Nigel Greenwood Inc., in London in January 1971. He would also visit the Continent for a series of significant group and solo exhibitions. In 1970, he travelled to Venice to make a work for the Biennale, *Chocolate Room* (remade several times, fig.51). The curators of the United States section of the exhibition had decided to focus on contemporary printmaking and graphics, and participating artists were invited to make editions in a print workshop created on site. In protest against the Vietnam War, against which activism was gathering pace, Ruscha considered declining the invitation (at one stage, as if he were still at school, he had his mother write a note excusing him from participation). In the end, though, he went ahead, and created a dramatic installation by silkscreening 360 sheets of paper with Nestlé chocolate paste (bought in tubes from a local supermarket) and completely wallpapering the space, achieving a piece that evokes all the senses, including the ideas of taste and smell. This was his first installation, and also his first experience of audience participation: reportedly, during the course of the exhibition, visitors traced anti-war graffiti into the soft, chocolatey surfaces, and so a protest of sorts emerged spontaneously. Like Kaprow's *Fluids*, the installation involved gradual decay over time, and the paper was discarded at the end of the exhibition's run.

Although Ruscha was primarily motivated by the material qualities of the chocolate, and its potential for printing, its symbolism cannot be ignored. The gesture of excess in papering a wall with rich chocolate at this point in time could be read as representative of the gluttony of the West in contrast with poverty in South-East Asia. In this context, the power of chocolate as a metaphor relates to the allegorical scenes of seventeenth-century Dutch still-life paintings, where towers of plump apples, oranges and grapes represent fecundity, and wilting flowers or rotten fruit the transience of human life. Surrealists, too, used food in their art, often with reference to sexuality or sensuality, and in the 1960s, the Viennese Actionists staged carnivalesque performances using meat and blood as props. As a Catholic, Ruscha would have

SWEETS, MEATS, SHEETS from
the TROPICAL FISH SERIES 1975 [52]
Screenprint with lacquer
83.2 x 65.4 (32 3/4 x 25 3/4)

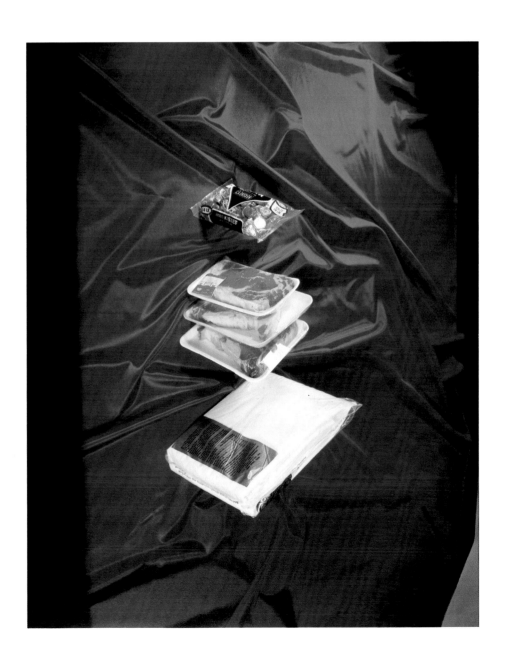

Still from PREMIUM 1971 [53]
By Edward Ruscha from a short story
by Mason Williams. Made after the
artist's book *Crackers* was published
(1969).

ART NEWS, SWEET AND SOUR 1972
[54]
Magazine cover, April 1972

grown up with an emphasis on food (the body and blood of Christ) – as well as the 'word' – in the doctrine of transubstantiation.

Ruscha's working *with* food also conflates the traditionally 'female' domain of the kitchen with the space of the studio (he prepared the materials by crushing food with a pestle and mortar). In Ruscha's 1972 film *Premium*, these also merge with the space of the bedroom. The film is based on a short story by Mason Williams ('How to Derive the Maximum Enjoyment from Crackers'). In 1969, Ruscha made the story into a picture book, *Crackers*, but felt it didn't really work in this format, and was better suited to the medium of film. In the celluloid version of this kooky fantasy, we watch the moustachioed star (artist Larry Bell) shopping for vegetables, and then – to our bemusement – arranging an intricate 'bed' of salad beneath the sheets in a seedy hotel room. He invites his date over and persuades her to get into bed. After seasoning her with oil and vinegar (fig.53), he makes his excuses and escapes in a chauffeured limousine. The final shot is of him eating crackers in bed alone in a plush hotel suite.

Leftover food, perhaps wasted or rotting, is used by Ruscha in other works of the time. Change and decay would also be referenced in his 1971 text *The Information Man* (p.42). For the April 1972 cover of *Artnews*, he composed a photograph that spelled out the magazine's title in a salad of squashed foods, both sweet and savoury: berries, bananas, peppers, kidney beans and anchovies (*Art News, Sweet and Sour*, fig.54). The picture references Giuseppe Arcimboldo (*c*.1530–93), who created fantastical portraits composed only of vegetables, fruit and flowers, and also refers back to Ruscha's own liquid paintings such as *Ripe*, where the letters of the title appear to melt on the canvas. One imagines Ruscha's studio at this time

full of food; in an interview, he talks of the lettuce he was using 'drying out, leaving little flies behind it'. *Insects* 1972 is a portfolio of six screenprints of houseflies, black and red ants and cockroaches, some on paper-backed wood veneer to give the impression of the creatures crawling around on a table-top (fig.55). The portfolio was covered with soil collected from the playground of Hawthorne Elementary School in Oklahoma City. Flies crop up 'actual size' in many Ruscha works, and are the subject of some: an early drawing, *Insect Eating Paper* 1960 (fig.60), shows a tiny mite chomping its way to the middle of the composition through the papery pulp; the lettering in the screenprint *I'm Amazed* 1971 is covered – perhaps in the process of being eaten – by a swarm of flies. Ruscha also used a convergence of insects to spell out the title of the poster and catalogue for *Documenta 5* (1972), the high-profile international art show held in Kassel, West Germany. All refer to a diagrammatic drawing of beetles by the German Dadaist J.T. Baargeld that Ruscha viewed at the Museum of Modern Art in New York back in 1961.

After this increased prominence in Europe, Ruscha consolidated his artistic reputation in the United States with his first solo show at Leo Castelli in New York in February 1973 (he would remain with Castelli until the dealer's death in 1999). The same year, in Los Angeles, he showed works made with organic materials and the *Stains* portfolio at the new Ace Gallery on La Cienega Boulevard.

Following experiments with food in prints and photographs, Ruscha adopted the strategy of staining the surfaces of his canvases with organic substances (the juices of crushed foods) rather than painting them in oil. This use of unconventional, transient materials in painting marked a further break with modernist tradition. Ruscha had been frustrated with the act of

FLIES 1972 [55]
Screenprint on wood veneer paper
51.1 x 68.6 (20 1/8 x 27)

GUACAMOLE AIRLINES 1976 [56]
Spinach stain on paper
57.8 x 72.7 (22 5/8 x 28 5/8)
Private collection

painting, commenting in a 1972 interview, 'I can't bring myself to put paint on canvas. I find no message there anymore.'[72] *Sand in the Vaseline* 1974, a word painting created with egg yolk on moiré, was later immortalised as the cover of a Talking Heads compilation album (*Popular Favourites 1976–1992*). The phrase seems to sum up this period of playfulness and experimentation – teasing the brain like an itch that needs to be scratched. Just as some of his previous word paintings demand to be 'said' aloud, such works encourage us to imagine the textures of the materials listed in their captions. For the backgrounds, Ruscha worked first on raw canvas and paper, and later on more absorbent fabrics such as satin, rayon and moiré (see *Cotton Puffs* 1974, egg yolk on moiré, fig.58). The tactility of these fabrics appealed to him, as did the similarity between the words 'stain' and 'satin'. Although he often stresses that the juxtapositions of words and medium are not predetermined, the materials he uses for painting often match the phrases painted in mysterious ways, and prompt the viewer to make connections between them, completing the rest of the story. *An Invasion of Privacy* is created with grass stains on raw canvas – Ruscha's notebook says, 'all letters rubbed in with grass from Samantha's lawn' (the actor Samantha Eggar being a girlfriend of the time). *Executive Pressures and Loss of Memory* is created with a disappearing haze of egg yolk, *Sea of Desire* with hot sauce on moiré. In *Various Cruelties*, the dark blueberry rubbing, which is soaked into the blood-red rayon crépe, evokes the stain of crimes that cannot be erased. The text of *She Didn't Have to Do That* 1974 (fig.59), Ruscha's notebook relates, is made from four samples of blood 'from Dr Pressler's office'. The misalignment of the four letters of 'that' implies a sense of instability presumably caused by the actions of the girl referred to in the picture.

I PLEAD INSANITY BECAUSE I'M JUST CRAZY ABOUT THAT LITTLE GIRL

I PLEAD INSANITY BECAUSE I'M JUST CRAZY
ABOUT THAT LITTLE GIRL 1976 [57]
Pastel on paper
57.8 x 73 (22 3/4 x 28 3/4)
Tate and the National Galleries of Scotland.
Acquired jointly through The d'Offay Donation
with assistance from the National Heritage
Memorial Fund and The Art Fund 2008

Phrases

Painting with egg yolk, grass stains or spinach juice, Ruscha was unable to achieve the *tromp l'oeil* effects of his earlier 'liquid' words. Instead, the stained canvas works were executed in a neutral typeface, using capital letters. Moving on from single words, he began to play with whole phrases, both in these works and in drawings also executed in neutral white type on a stained background (lettuce, carrot juice) or bright pastel ground. It's hard to convey the potency of these works without listing their titles, snippets of conversation and odd declarations: *Pr-Pr-Process Food*; *A Winter Vegetable Set-up in Mexico*; *Nice, Hot Vegetables*; *I Plead Insanity Because I'm Just Crazy About That Little Girl*; *Honey I Twisted Through More Damn Traffic Today*; *Wash, Then Dance*; *Headlights are Similar to People's Eyes*; *Malibu = Glass Sliding Doors*; *I Don't Want no S-Silicones or No Accidental S-Sideburns ...*

Legibile and authoritative like painted signs, these statements look bold and factual even when the phrases are kooky. In their shape, they recall billboards or public-information signs, such as the Highway sign in the Steve Martin film *LA Story*. And like that sign, each can be seen as a puzzle or teaser. No longer detached objects, these words are now contextualised in sentences; instead of looking at the patterns of the letters, one has to think, read, digest and process. Dave Hickey has referred to Ruscha's word phrases collectively as 'Wacky Molière Lines' – an alternative pronounciation of *Guacomole Airlines* in a Southern US accent; the critic described how he would pin the works up on his wall, and once he 'got' the point of one, he would remove it, and move on to the next.

Thus Ruscha's work underwent an evolution in the 1970s. Words became sentences, and the new organic materials he used in printing, photography and latterly painting extended the poetry of his 'liquid' word works. He would continue using unconventional materials, for example in a 1997 series entitled O Books, where he painted with bleach or ink on the linen covers of second-hand hardback books – a natural extension of the idea that his works 'are titles for imaginary books'. Themes of change and decay would also be explored in the 2005 series of paintings *Course of Empire* (see pp.106–9).

COTTON PUFFS 1974 [58]
Egg yolk on moiré
91.4 x 101.6 (36 x 40)
Daniel Loeb and Margaret
Munzer, New York

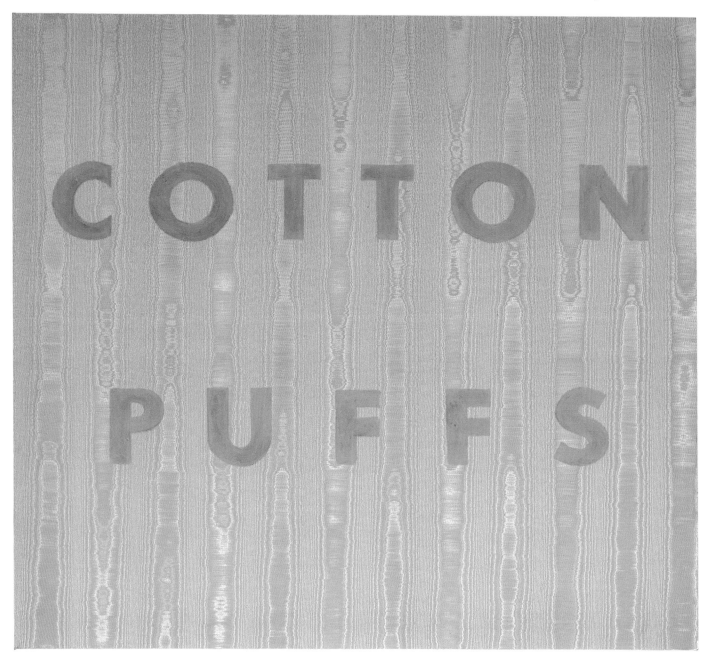

SHE DIDN'T HAVE TO DO THAT
1974 [59]
Blood on satin
91.4 x 101.6 (36 x 40)
Ringier Collection, Zurich

Drawing has always been central to Ruscha's practice, and ever since his student days his works on paper have served as an end in themselves rather than simply a means of thinking through ideas or planning compositions. As was evident at an important survey of drawings at the Whitney in 2005 (*Cotton Puffs, Q-Tips, Smoke and Mirrors* – a reference to the tools he uses and the idea of the artist as a magician), these works, taken as a collection, cover a wide range of styles and techniques, and their trajectory is akin to the development of his paintings. Every phase is represented: there are liquid words (*Pool* 1968, p.55), 'cut' paper works (*OKLA.* 1968, p.54) and experiments with delicate substances (*Hostile Polyester* 1977, lettuce on paper then coated with polyurethane); material innovations such as pastels or graphite mixed with gunpowder (*Whiskers, Splinters* 1972); and acrylic paint applied in smooth layers with an airgun, creating a luminous foggy atmosphere (*Homeward Bound* 1986, p.84). The two examples shown here are experiments with trompe l'oeil nearly fifty years apart: *Insect Eating Paper* 1960 (fig.60) and *Broken* 2007 (fig.61).

Ruscha has also used drawings self-referentially, making images of his books, photographs and recurring motifs (gas stations, objects floating in space, liquids, ribbons, pieces of paper, favourite words and phrases).

MARY RICHARDS You've spoken about your childhood and the inspiration of Higgins India ink, especially in relation to your drawings and works with different juices stained on paper. Could you talk a bit about the physical processes of making these works?

ED RUSCHA Well, going back to my early years, I would say that that India ink was my first touch with aesthetics. I had a neighbour down the block who used to draw cartoons. He had a bottle of Higgins India ink, and it had a very distinctively shaped bottle with a funny shaped crown cap on it, rubberised. It had a dipper in there, so that you could squeeze it like a squeeze bottle, and put it in a pen, or put it off to the side, or even draw with it. The black ink on white paper was powerful to me; even when it piled up and dried and cracked, it had a certain attraction to me that I equated with comic strips and cartoons, because cartoonists have used that type of ink since the early days. So cartoons, and especially those done with India ink, were two features that went back in my history, before I even saw an oil painting. And somehow it really figured into what I began doing as an artist. I still feel that way. Most of my feelings today are based on things that occurred a long time ago, when I was eighteen years old. And drawing, or working on paper, afforded me a way to make some kind of off-campus kind of statement that was not in the mainstream of thinking, which is painting to me. So when I made drawings, they weren't cartoons or studies, they were end results. I started using powders and pigments and making shaded images that I

didn't try to emulate in the field of painting. Almost all of my drawings, with only a few exceptions, were end results rather than studies for paintings. I'm not a zealot about that either – I don't discount artists who do studies in the form of drawings for paintings, because some of them do it so well. But sometimes even today I'll make works on paper exactly like I would make a painting. It just happens to be on a different support. Instead of canvas, it's on paper.

MR And it's quite hands-on and physical, when you're working with different materials? Can you explain how you work with gunpowder?

ER The gunpowder thing came about almost by accident. I was using graphite that I would make into powder. Graphite was a very oily material to use, and yet I could get these shadings that I liked. And I just happened to have a can of gunpowder. This was granulated, and then I began thinking about creating pictures using some kind of granulated materials, either from granules or fine powder. And then charcoal powder also ... I thought, well, gunpowder is part charcoal anyway, so let's just see what happens if I use the gunpowder. In order to make it more powdery, rather than pellet-like, I had to soak it in water, and all the salt came out of it, so I just discarded the salt and used this sulphur. (I'm not a chemist, but I think gunpowder is made up of sulphur and charcoal and salt, and maybe a few other things.) Finally I just reduced it down to this black powder, which was quite different from graphite. It was dryer and it was more powdery, and any mistakes were much easier to

correct. So I just started doing these things with gunpowder, and that evolved into using organic materials. I wanted to leave tradition behind in some way or other. So I also started using natural liquid materials – even the liquid that comes out of rose petals would make marks. That took me off in a different direction.

MR So it was the work you were doing at Editions Alecto in London that started that off?

ER Yes. I was invited to go there, and I really had no idea of what I was going to do, and just experimented with a few things involving silkscreen printing. And then I made this plunge off into experimenting with things like chocolate, axle grease, caviar. I even used some kind of cream. Some substances didn't work; they didn't maintain their images – they would just bleed into nothingness. So I wanted to focus on materials that would be stable enough, although over time I had no idea how long these things would last. That was really beside the point, and I didn't care.

MR It seems quite primitive, like making your own paints in a way. You must have been aware of the poetry of it as well. Particularly with those drawings, the medium is often as interesting as the rest of the information in the caption; it all adds to the sense of the thing.

ER Yes. And the question of the stability comes when you've almost got invisible fingers wagging at you saying, 'Is this going to last?' I had to ignore that and go for what I thought might or might not be stable. As it happens, most of those materials have maintained themselves. Sometimes I've

INSECT EATING PAPER 1960 [60]
Collage on paper
27.9 x 27 (11 x 10 5/8)
Whitney Museum of American Art,
New York

BROKEN
2007 [61]
Acrylic on museum board paper
31.1 x 23.8 (12 1/4 x 9 3/8)
Gagosian Gallery

used jellies and jams that got attacked by mites!
And salmon roe – that was a substance that was
mixed in paints centuries ago. It was rather dull,
golden-ish dull. Today when I look at them,
thirty-five years later, they're actually brighter
than they were before. But I've kept them out
of the sunlight. But then I've used other materials
that have totally faded, like Pepto-Bismol, or
that have more or less lost their elasticity and
have gone to powder.

MR I like the idea of the works being attacked by
mites – especially in relation to your other
drawings and prints with ants crawling all
over the surface.

ER Yes, I'm not sure where all those things criss-
cross each other. That's not important to me.
These are the different elements I work with
that I can't explain.

MR You've described the process of doing the back-
grounds to your paintings as quite robotic. Do
you take the same approach with your drawings?

ER Sometimes, and sometimes not. It's hard to
say. I don't want to continue making the same
picture forever, so if I have a set of approaches
or techniques that I use, I don't want to
compulsively repeat those techniques. I find
myself side-stepping those, and doing things
in different manners, rather than the
side-to-side action. It's just another aspect of
my work.

MR Do you have a favourite drawing, or set of
drawings? Do you not think in those terms?

ER Some are drawings that didn't have any overt
aesthetic properties to them. I did a little drawing

of the word 'jelly', which is just black ink on
white paper, and it didn't have any of the usual
art-making things to it. It was just hard and
in-your-face. So I appreciated that for what it
was. I didn't do a lot of works like that, but I look
back on it, and that's one drawing I really like:
the word 'jelly'.

ORANGES, PEACHES, PEARS, APPLES, GRAPES, YOU NAME IT

ORANGES, PEACHES, PEARS,
APPLES, GRAPES, YOU NAME IT
1977 (detail) [62]
Oil on canvas
55.9 x 203.2 (22 x 80)
Collection Helen N. Lewis and
Marvin B. Meyer, Beverly Hills

'TALK ABOUT SPACE'
AMERICAN LANDSCAPES

5

In 1976, in need of a retreat from the city, Ruscha began building a desert home in the Mojave, close to Joshua Tree National Monument. Construction was completed in 1981. At 5,000 feet above sea level, the location afforded excellent light and views across the region. Since the late 1950s, Ruscha had been painting words – and, latterly, phrases – in the abstract 'space' of canvas or paper. From this point onwards, perhaps as a result of his new surroundings, he began siting them in landscape vistas and skies, and painting in oil and acrylic with renewed vigour. The introduction of fragments of recognisable motifs, either from the natural world (the line of a mountain, the shadow of a wild animal) or from the urban landscape (the grid of the city or outline of a suburban home) was a significant new development; eventually, as we shall see, words would disappear from some paintings altogether.

Desert Skies

The new 'widescreen' landscapes, which Ruscha called Grand Horizontals, are cinemascopic in their proportions; they are also filmic in feel, with intense technicolor skies resembling studio backdrops, and odd phrases that hover in space like title credits or the Hollywood sign against the side of a mountain (see p.114). *Oranges, Peaches, Pears, Apples, Grapes, You Name It* 1977 (figs.62, 93) is typical of these works, which range from two to four metres wide and are therefore difficult to appreciate in reproduction. This particular title initially seems to be a pun on the colours in the painting (orange and peach being colours as well as fruit). The phrase also works as a reference to the wealth of produce that can be harvested in the state's climate; the scene could almost be a billboard advertisement for California. The words float just above a dark line of mountains, their small white type dwarfed by a dramatic blue and orange sunset; trippy and alien, it could be in the Mojave or it could be Mars.

Critics have noted that in their palette and scale the Grand Horizontal works recall the nineteenth-century Hudson School artists such as the British-born Thomas Cole, whose *Course of Empire* Ruscha would later reference directly (see pp.106–9), his pupil Frederick Edwin Church or the German-born Albert Bierstadt (see p.86). Their Romantic vistas depicted the American wilderness as an earthly paradise or Garden of Eden. Precise attention to detail allowed the viewer to experience the Sublime in dramatic storms, sunrises or sunsets without travelling to the remote locations presented on the canvas.

In a statement similar to his dismissal of the photographic nature of his books, Ruscha is typically evasive about the landscape-ness of his landscapes:

*A lot of my paintings are anonymous backdrops for the drama of words. In a way they're words in front of the old Paramount mountain peak. You don't have to have the mountain back there – you could have a landscape, a farm. I have background, foreground. It's so simple. And the backgrounds are of no particular character. They're just meant to support the drama, like the Hollywood sign being held up by sticks.'[73]

Yet in Ruscha's pictures, the concepts of space and time, microcosm and macrocosm – themes with which one might typically be confronted when viewing a traditional landscape scene – are indeed evoked, not just by the motifs of mountains and skies, but by their combination with playful text, diagramming and listing. *Who Am I?* 1979 (fig.64) is one of only a handful of his works containing a figure, pictured here as a tiny silhouette standing on a mountain in a wide expanse. The figure's existential questions –'Who Am I?', 'Yes, That's Right, Who Am I?' – are swallowed up by a vast red and black desert. This text sums up the laconic wit

WOLVES, EXPLOSIONS, DISEASE,
POISONS – HOME 1980 [63]
Oil on canvas
55.9 x 203.2 (22 x 80)
Private collection

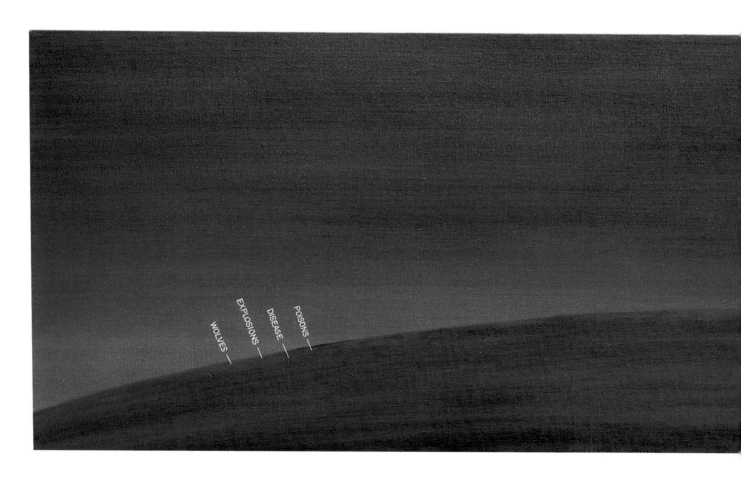

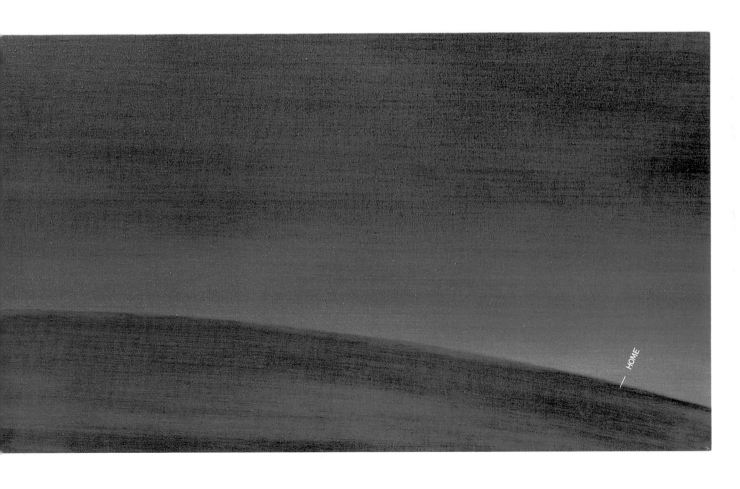

WHO AM I? 1979 [64]
Oil on canvas
55.9 x 203.2 (20 x 80)
Private collection, Chicago

of Ruscha's art, almost mocking the earnestness of earlier, more angst-ridden, generations of artists and their attempts to describe natural phenomena.

Other canvases contain the motif of the Earth as if viewed from outer space; yet the tiny globe of *It's a Small World* 1980 (fig.65) is given no more significance than the spheres of 1960s works with bowling balls, marbles and olives. Ruscha also painted constellations, enveloping blue-black grounds punctuated by tiny stars (*Big Dipper* 1980). That year, he was commissioned to design the exterior of a private jet, owned by collector Frederick Weissman. He chose a galaxy of stars. His friend and fellow artist Joe Goode designed the interior.

Ruscha also used the horizontality of these pictures metaphorically. *Wolves, Explosions, Disease, Poisons – Home* 1980 (fig.63) uses its own length to represent the distance between two opposing states of mind: fear of the unknown and the security of the familiar. The same is true of the skinny, ribbon-like canvases, whose length recalls *(Every Building on) The Sunset Strip*. Their titles, written as diagrams on the edge of the Earth or floating in the airspace, are particularly playful: *Serenity, Comfort, Relief – Tension, Harassment, Problems*; or *Ancient Dogs Barking – Modern Dogs Barking*, both 1980. In these works, which are four metres wide, the phrases are pictured so far apart that one must walk from one side to the other to read the text, incorporating the idea of space and time into the viewing of the picture. 'Their visual perspective rejects the static easel tradition in favour of the mobile screening of the car window', wrote critic Neville Wakefield.[74]

As is often the case with Ruscha, many of the landscapes seem to refute any relationship between the text and the backdrop, simply mapping incongruous lists in the sky or diagramming them onto the land

(*Days of the Week* 1979). Among the inventories that Ruscha covers are lists of US and other cities (*A Question of Cities* 1979, *Cities Across the Globe* 1980); Los Angeles locations (*The Canyons* 1979); decades (*The Sixties & Seventies* 1979); and other miscellaneous listed items such as *Various Plastics* 1979. He would perform a similar strategy in the late 1990s, mapping Los Angeles street names in the foreground of dramatic mountain landscapes (see *Alvarado to Doheny*, p.100).

In conjunction with the diagrammatic form of the landscape, during this period Ruscha began almost exclusively using what would become his trademark typeface, which he describes as 'no-style' or 'Boy Scout Utility Modern'. The features of the type are cut-cornered from the squared-off edges, like the letters of the Hollywood sign; it is as if the characters have been formed only of cut pieces of tape (like his ribbon works on paper). They attempt to be 'neutral', like the photographs in his books.

Nocturnes

In March 1982, Ruscha enjoyed his first major US retrospective, a mid-career survey organised by the San Francisco Museum of Modern Art, travelling to the Whitney in New York, Vancouver Art Gallery, San Antonio Museum of Art, Texas, and finally to the Los Angeles County Museum of Art in 1983. A wry 1979 pastel announcing *I Don't Want No Retro Spective* graced the cover of the Ruscha-designed catalogue. After this significant show, a large part of the following decade was dominated by his first public commission, a series of site-specific paintings for the new Miami-Dade Public Library in Florida (see pp.90–3). The creation of the project's centrepiece – a huge, eight-panel oil for the building's rotunda – required an enormous working space, and so in February 1985, he relocated from the Hollywood studio he had inhabited

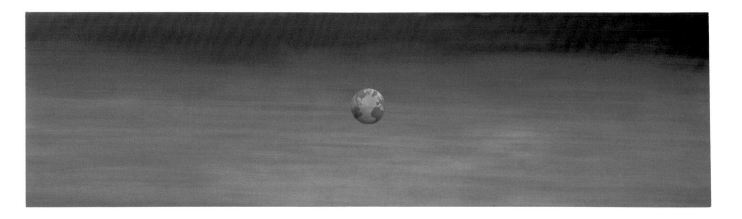

IT'S A SMALL WORLD 1980 [65]
Oil on canvas
55.9 x 203.2 (22 x 80)
Collection Candy Clark

TALK RADIO 1987 [66]
Acrylic on canvas
147.3 x 147.3 (58 x 58)
Private collection

for twenty years to a large industrial unit, an old Coors beer warehouse near Venice Beach, where he still works today. Its ample proportions meant that he could work on all the panels of the Miami work simultaneously, literally surrounded by the paintings; he also had the option of creating even larger works in the future. In these new 'factory' surroundings, and due to a desire to achieve a smooth finish at increased speed, Ruscha began working in acrylic paint using an airbrush, a tool normally associated with commercial practice.[75]

Once again, a change of tools would transform the look and feel of his paintings ('I began to dislike brushstrokes and awoke to subjects that looked out of focus'). Previously, 'robotic', horizontal strokes in graded colours had been achieved by hard labour, the artist slowly building up the oil pigment line by line to create a smooth finish and a gradual bleeding of one colour into another. Now, by spraying fine layers of acrylic on canvas or paper with the gun, he was able seamlessly to blend colours, and achieve in paint subtle effects previously reserved for his pastel and gun-powder drawings.

Lights, shadows and fog became the dominant imagery in this period of work. For the library commission, Ruscha spent much time travelling by plane between Los Angeles and Miami, and the bird's-eye view from the passenger seat inspired a series of City Lights, nocturnal aerial views of these cities' urban sprawl. In *Talk Radio* 1987 (fig.66), words in a handwritten font hover above a grid of tiny lights glowing in the midnight sky. In this case, the multitude of miniature dots suggests a population of listeners tuning in for a fix of radio banter. 'A lot of my ideas for my art come from the radio', Ruscha said in a later interview. 'I like the texture. It's best when it's music overlapping talk, or talk over talk.'[76] A few years

HOMEWARD BOUND 1986 [67]
Acrylic on paper
152.7 x 102.2 (60 ⅛ x 40 ¼)
Private collection

BRAVE MEN RUN IN MY
FAMILY 1983 [68]
Oil on canvas
244 x 183 (96 x 72)
Private collection

earlier, in 1984, he had taken a small role in his friend Alan Rudolph's film *Choose Me*, playing the producer of a radio station; most of his time on screen was spent looking through a studio window at the words 'talk radio'. Fragments of conversation also form the titles of other works in the series – *Wen Out For Cigrets*; *Where Are You Going Man*; *Faster Than a Speeding Beanstalk*; *Didja*. Dislodged from their original context (which we can only guess at), these words are left suspended in the air, searching for meaning. Their 'handwriting' points up the fact that these are words transcribed directly from Ruscha's notebooks, which he uses to record lists of particular words or phrases that grab him. The use of colloquialisms, slang and abbreviations is further evidence of the delight that he takes in language; by making these throw-away remarks the focus of huge canvases, he gives epic status to the mundane. He would continue depicting lights and shadows in a series of works featuring a light beam (p.121) and the urban landscape in his Blue Collar paintings (p.102).

The most significant development of this time was a series he called 'Silhouettes' or 'Nocturnes', enigmatic scenes created in a monochromatic palette of smoky greys and blacks, inspired, he says, by the idea of 'black ink on white paper', black-and-white films and the paintings of Franz Kline. In their misty haze, they are reminiscent of early photography; one also thinks of Warhol's film *Empire*, showing the iconic Empire State Building in shadow against a grainy sky. For his subjects, Ruscha chose simple, picture-book images that would easily be recognised in silhouette form – though his treatment of these suggests a seedy underbelly. The images, which appeared literally to be projected onto the canvas in soft focus, were archetypes, created by morphing images from memories of childhood books and

magazines into an ideal shape. They were usually used in more than one work. In the drawing *Homeward Bound* 1986 (fig.67), a ghost-like galleon emerges through fog, recalling in shadow form the schooner of an earlier painting *Brave Men Run in My Family* 1983 (fig.68). The latter image was a photo-realist collaboration with fellow Los Angeles artist Nancy Reese (she did the painting, he the lettering).

One wonders why Ruscha's imagery changes so drastically at this point. Might the blackness reflect a growing cynicism with the American dream? If his early paintings and books represent Los Angeles's 'sunshine image', perhaps these new canvases reference its flipside, or 'noir', its smoggy air an indication of the promise of the city gone sour. *Name, Address, Phone* 1986 (fig.72) shows a tree-lined residential street silhouetted against a smoky ground, like a ghostly apparition of Ruscha's *Los Angeles Apartments*. Its composition here evokes the camera angles, high-definition shadows and imagery of film noir, creating the impression of surveillance, as if the viewer is lurking in the bushes in the foreground. In its mysterious darkness, it evokes the mood of a Raymond Chandler novel, such as *The Big Sleep*: 'Ten blocks of that, winding down curved rain-swept streets, under the steady drip of trees, past lighted windows in big houses in ghostly enormous grounds, vague clusters of eaves and gables and lighted windows high on the hillside, remote and inaccessible, like witch houses in a forest.'[77]

Ruscha's imagery also relates to the historical American West. In *Uncertain Frontier* 1986 (fig.70), a string of horse-drawn wagons, recalling the fortune seekers of *The Grapes of Wrath*, travel across Ruscha's favourite compositional diagonal. *The Tepees* features a line of tepees, just visible through smoky air. Both of these motifs can be found in nineteenth-century

Albert Bierstadt
EMIGRANTS CROSSING THE PLAINS
1867 [69]
Oil on canvas
170.2 x 259.1 (67 x 102)
National Cowboy and Western
Heritage Museum, Oklahoma City

painting, for example Albert Bierstadt's *Emigrants Crossing the Plains* 1867 (fig.69), which captured in paint the concept of Manifest Destiny, depicting a long line of wagons and cattle progressing across the canvas towards the Western sunset. One can just make out a group of tepees, camped safely at bay in the far distance. Images such as these would later become common currency in pulp Westerns and Hollywood films. The notion of adversity can be read in to Ruscha's other silhouetted subjects, an elephant or a car travelling uphill (*Jumbo* 1986 and *Uphill Driver* 1986). He said, 'As I started to work on these things, I could see they reminded me of some kind of narrative or story about struggle.'[78]

These canvases can also be compared with James Abbott McNeill Whistler's own series of Nocturnes. In *Nocturne: Blue and Gold – Old Battersea Bridge* 1872–5, the bridge of the title looms large in the foreground. Whistler was inspired by the reality of urban landscape, the mist and coal-smoke of polluted industrial London that he viewed from his window on the Thames (which in the 1840s experienced thick yellow 'pea-soupers'), and also by the poetic imagery of the idea of night closing in as a metaphor for life and death. Although Ruscha would be reluctant to tie this new direction in his work to biographical events, these Nocturnes could perhaps also be linked to the death of his mother Dorothy on Christmas Day 1985. The shadow of a church appears in many of the pictures, and in some, Joshua trees loom large in the foreground like a crucifix.

The Silhouette paintings also incorporated images that Ruscha had been using for over twenty years: the Standard Station (*Untitled* 1989), cacti or Joshua Trees (*A Fistful of Aliens* 1986); houses (*Name, Address, Phone* 1986). The recurrence of motifs in silhouetted forms recalls Duchamp's 'widescreen' painting *Tu M'*

1918, a work in which the shadows of his readymades (a bottle rack, a bicycle wheel) appear to be projected across the canvas. As with Duchamp, there is much cross-pollination in Ruscha's work – photos become paintings, paintings drawings, books transform into paintings and drawings, a lexicon of images, techniques and media to be drawn on at any time.

In particular, the series signalled a radical departure for Ruscha in that his trademark words or phrases were displaced from the main body of the paintings to their titles. In many, black or white 'blanks' or 'censor strips' were included, to suggest where these 'missing' words would have been placed. For an artist who had devoted much of his career to creating worlds out of words, their displacement seemed surprising ('these newer works I'm doing seem to come from their asking to be titled – the titles are sort of glaring').[79] The blanks call on the viewer to decipher the image and 'complete' the picture in the space provided. In *Name, Address, Phone*, the blank boxes stand in for the words of the title; they could also symbolise the erased or censored details of the actual residents.

Ruscha would continue to use the motifs of American history, combined with silhouettes and blanks, into the 1990s. In a seventy-panel, 360-degree work made for the atrium of the Denver Central Public Library (1994–5) he created 'a rolling historical landscape',[80] evoking the history of Colorado and the American West. Silhouettes of teepees, buffalos and larks, a steam train and wagons were overlaid not with 'blanks', but with symbols and waveforms (sound-prints of birdcalls, buffalo stampedes and snorts) and anamorphic text that could only be read when viewed from a particular vantage point – like the skull motif in the most famous painterly optical illusion, Hans Holbein's *Ambassadors*. The text singles out legendary characters in the region's history, 'Ouray, Ute Jack,

UNCERTAIN FRONTIER 1987 [70]
Acrylic on canvas
55.9 x 203.2 (22 x 80)
Orange County Art Museum,
Newport Beach, California

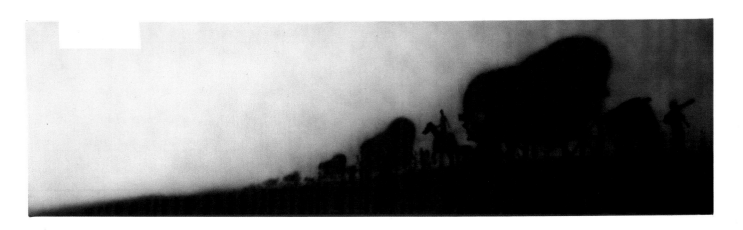

BE CAUTIOUS ELSE WE BE
BANGIN ON YOU 1997 [71]
Bleach on fabric on board
50.8 x 40.6 (20 x 16)
Private collection

Colorow, Black Kettle and Chipeta, all leaders of the Ute Indian Tribe'; 'Baby Doe, beautiful wife of mine owner Horace Tabor'; and 'Soapy Smith, a famous Western flimflam man'. The novelty of the Denver work was the creation of a new 'sign' language, substituting his user-friendly typeface for symbols and abstract waveforms that could not be 'read' in the normal way. Ruscha's paintings thus entered another dimension – not only were there shadowy forms or blank boxes to trigger the imagination, but also symbols and coded text to decipher.

The 'blanks' would also feature in a series of Cityscapes or 'censored' word works, for which Ruscha eschewed imagery altogether. Though the pictures were minimal, containing only stacked 'blocks' of colour, like bricks, their intriguing titles consisted of threats or accusations expressed in street slang: *Be Cautious Else We Be Bangin on You* 1997 (fig.71), or *I Might Just Get Ugly if You Get Up on That Stand ...* 1997. He had long been interested in vernacular text, inspired by such diverse influences as Gangsta rap and Mark Twain's 1895 novel *The Tragedy of Pudd'nhead Wilson* (the print series *Sayings from Pudd'nhead Wilson* 1995 reproduced phrases like 'Dis Ain't What you's Gwyne to Try to Do, It's What You's Gwyne to Do'). Ruscha created many of his 'censored' words in bleach on canvas, rayon or linen, a substance that evoked the idea of censorship by literally as well as metaphorically eating away at the text. Some of them re-used the robotically painted canvas backgrounds of his 1960s liquid-word paintings, such as *Note We Have Already Got Rid of Several Like You One Was Found in River Just Recently* 1996. Formally, and in their palette, they seem to be in dialogue with colour-field painting (such as the work of Ad Reinhardt), though as with all of Ruscha's work, any 'abstract' device is always representative of something. The 'blanks' – white or coloured rectangles – echo the configuration of the sentences in the title; like a code, the length of the box relates to the length of the word. The blanks censor or conceal the violent sentiments expressed in the titles, and in this way the maroon canvases seem to evoke blood stains, the blanks representing plasters or gags. He would later create a print series, Country Cityscapes, where the same blanks are superimposed over photographs of idyllic rural scenes of lakes, deserts, mountains and pines.

The 1970s and 80s saw Ruscha exploring a range of new ideas, and the art he was producing by 1990 was radically different from earlier works. Words and objects still hover in front of backgrounds that, though minimal, now frequently represent a physical place rather than space itself. The new technique of airbrushing would lend a very different textural character to these works as clean lines give way to blurred edges. And we see the texts that are the hallmark of his painting up to this point disappearing altogether, to be replaced either by images, 'blanks' or empty signs, to create a complex 'map' for the viewer to decipher.

NAME, ADDRESS, PHONE 1986 [72]
Acrylic on canvas
149.9 x 369.6 (59 x 145 ¹/₂)
Private collection, Tokyo

The Miami-Dade Library project was Ruscha's largest undertaking to date. The artist was commissioned to make site-specific works for a new library building in a cultural complex in downtown Miami that had recently been designed by the architect Philip Johnson. A detailed account of the project is given in a catalogue produced by the Lannan Foundation in 1989, and the quotations in the text below are taken from two proposals that Ruscha submitted (reproduced there in full).

The commission was undertaken in two parts. The first, the cornerstone of the project, was a painting for the circular rotunda in the lobby of the building (fig.73). Over a background of wispy skies in varying colours – from rich red sunsets to soft blue and yellow cloud formations – Ruscha painted the line 'Words Without Thoughts Never to Heaven Go', a quotation from Shakespeare's *Hamlet*. In his proposal of April 1985, the artist said: 'This noble quotation is as timeless as it is poetic. It is a quotation that is profound and yet simple. For me it burns with curiosity.' In work of the time he had begun using imagery and text relating to Heaven and Hell (*A Particular Kind of Heaven*, p.102, and variations on the theme *90% Devil, 10% Angel*). The idea of a ring of words is reminiscent of a halo.

Ruscha originally intended to paint the mural on a single, ribbon-like canvas, 126 feet long, but after consultation with engineer Ron McPherson, he decided to stretch canvas over eight aluminium panels, which would be fitted together in situ. Each of the seven words in the sentence would appear on a separate panel, 'to cause the viewer to not only observe the thought as a whole, but to reflect for a moment on each word as an individual word and each picture as an individual picture'. The eighth panel, which Ruscha called the 'belt buckle', was left blank, allowing for a 'pause' in the contemplative experience, 'thus acting as a divider'. The text receded in size as the sentence progressed, as if the floating words, progressively light and insubstantial without thoughts to support them, were disappearing into space.

The rotunda panels were installed in July 1985, but the second stage of the project proved more problematic. An initial proposal to silkscreen 138 archway lunettes, each 6 x 12 feet, for the library reading rooms proved impossible to realise. Ruscha put forward a more modest proposal to hand-paint around forty 'that have the most meaningful and direct locations'. Their subjects would be relevant to a library in the sense that they would relate to language and the idea of learning. One series of lunettes contained single words, namely parts of speech – conjunctives ('and', 'if', 'so', 'but') and interrogatives ('who', 'what', 'why', 'when', 'how'). Another batch included soft-focus, silhouetted images of ships, representing discovery; maps of the world, representing knowledge; and rulers and hourglasses, representing science and mathematics. These motifs would resurface in other paintings, drawings and prints of the period.

Ruscha would produce another site-specific piece on the theme of words in 2002: *Words in their Best Order*, made for the offices of Gannett Company publishers in Tysons Corner, Virginia. This quotation is taken from Coleridge's *Table Talk* (1835): 'Prose = words in their best order; – poetry = the best words in the best order.'

WORDS WITHOUT THOUGHTS
NEVER TO HEAVEN GO 1985 [73]
Oil on canvas on eight aluminium panels
Each 160 x 487.7 (63 x 192)

MARY RICHARDS *Words Without Thoughts Never to Heaven Go.* That's a quotation from *Hamlet*, isn't it?

ED RUSCHA Yes, Act III, Scene iii, I think. 'My words fly up/ My thoughts remain below/ Words without thoughts never to heaven go.' It was in some ways an obvious application to an institution like a library. The painting that's in the rotunda is done in many colours, and the works in the rest of the museum, with their fanlight lunette shapes, were all done in black and white. It's a reflection of the insides of books, which have black ink on white paper. I would use colour in some of the words, but all of the backgrounds were black and white.

MR Did you think of the quotation in response to the idea of a library? Because you've made other paintings using those words subsequently, haven't you?

ER All those works were done at the same time, always with the thought of the library. The works are circular, because the idea is a full thought, 'Words without thoughts never to heaven go.' It's like a full thought that almost comes round and bites its own tail. So I would do circular things and then I would also do oblique things, as though you were looking at it from the sky, or up from under it; you know, taking a little trip with these quotes and making pictures out of it.

MR What do you think people using the library make of the work?

ER I think they'd better like it! I felt it was very successful. I came to this studio because of that library commission. I knew I couldn't paint that work in situ. I liked the idea that I was painting pictures in Venice, California, for a library in Miami, Florida.

MR You didn't like the idea of doing a Michelangelo?

ER No! I couldn't see myself doing that. This studio was perfect. I had the canvases mounted on aircraft aluminium panels. After they were painted, we put them in the back of a truck, almost like a pizza oven. I had a fabricator who helped me put that whole thing together. They needed plenty of drying time, and they needed to be separated so they wouldn't touch each other. And then, with Greg Colson, an artist and a friend of mine who was helping me at the time, I drove down to Florida and they were then put in position and bent into place.

MR That was the biggest thing you'd done at that point, in scale, wasn't it?

ER Oh yes, the biggest thing. When I was first offered that commission, I thought, 'This is too big for me.' But then I rethought it, and the challenge was too irresistible to pass up. I couldn't back away from this thing.

SCHWAB'S PHARMACY 1976–95 [74]
Photograph from altered negative
51.1 x 75.1 (20 1/8 x 29 9/16)

6

Many artists look back on their past work as though it's absolutely foreign soil, to be forgotten and sometimes rejected. And yet I feel like all my work comes from something much older than the individual painting. It comes maybe from where I was when I was eighteen years old. I feel the same way today as I did then.[82]

From the mid-1990s onwards, Ruscha began making works that, in many different ways, evoke the idea of the passage of time. This theme can be traced back to a pair of paintings that playfully compare two eras: the monochromatic seascape *17th Century* and its more colourful counterpart *20th Century* 1987–8 (figs.75, 76). The former picture is blurred, like an old black-and-white photograph, yet through the fog it's just possible to make out a tiny clipper on the horizon. *20th Century* also contains a distant vessel that might be a cruise ship or a liner. A string of nouns describing the earlier period sit in Gothic script over the clouds – *War! Alchemy! Damsels! Firewood! Taxes! Plague! Melancholia!* The summary of the modern era is painted in a more contemporary font: *Crime! Fuel! Business! Aviation! Law! Farming! Women! Medicine! Taxes! Lumber!* Many of the concepts listed are common to both eras but expressed differently – *damsels: women; firewood: lumber; alchemy: medicine* – though, amusingly, taxes are still taxes, whatever century you happen to live in. Ruscha's wry blankness leaves us to draw our own conclusions on the relative merits of these vastly different eras. Does the coloured sky in *20th Century* reflect the progression from a primitive society to modern state? Or is it filled with smog because of a burning oil spill?

Los Angeles Over Time

Ruscha had begun revisiting and re-presenting older series of his own works during the 1990s, a practice that would eventually lead to him revisiting individual canvases. In collaboration with his brother Paul, a photographer, he dug out the negatives of his 1960s and 70s photographs – some from his books, others from his photographic archives – and began remaking them as print portfolios. *Gasoline Stations* 1962/1989 and *The Sunset Strip* 1966/1976/1995 (fig.74) were the first examples of these. The latter series is transformed by their presentation in this new context. Whereas the 1966 book described a homogenous street, where every element is of equal importance to the whole, here Ruscha 'stripped' particular locations from their original context. These nightclubs, bars and eateries – Greenblatt's Deli, Filthy McNasty's, Liquor Locker, Whiskey A-Go-Go, Gazzarri's Supper Club and Schwab's Pharmacy – are now legendary, and their treatment evokes a nostalgia for times past. He was now operating the principle of choice and selection over the data he had collected earlier. Moreover, the new prints were created by taking a razor blade and sheet of sandpaper to blow-up copies of the original negatives, giving the new prints a weathered appearance, referencing the physical deterioration of the prints like an old film reel that crackles and jolts. In this way, they relate to a series of 'cinema screen' works that Ruscha had begun in 1991 (see p.119). His technique might also be compared to a music producer artificially 'aging' sampled fragments of sound to evoke the bygone era of old recordings. Other series of remade prints followed, and many were included in *Editions 1959–1999* originated by the Walker Art Center, Minneapolis, an exhibition (and catalogue raisonné) highlighting the importance of printmaking in Ruscha's practice. Some reproduce pictures from his books (*Pools* 1968/1997, *Parking Lots* 1967/1999, *Los Angeles Apartments* 1965/2003, *A Few Palm Trees* 1971/2003 and *Vacant Lots* 1970/2003); others present images from his archive, such as *Seven Products*

17TH CENTURY 1987–8 [75]
Oil on canvas
142.2 x 340.4 (56 x 134)

20TH CENTURY 1987–8 [76]
Oil on canvas
149.9 x 369.6 (59 x 145 ½)
Nagoya City Museum

ROOF TOP VIEW #6 1961/2003 [77]
Gelatin silver print
25.4 x 25.4 (10 x 10)

ROOF TOP VIEW #5 1961/2003 [78]
Gelatin silver print
25.4 x 25.4 (10 x 10)

1961/2003 (p.18) and *Roof Top Views* 1961/2003 (figs.77, 78), a series of photographs looking down on intersections in Los Angeles from a high vantage point.

Recording change in the streets of Los Angeles has long fascinated Ruscha, and he regularly documents Hollywood locations such as the Sunset Strip and Hollywood Boulevard; he also photographed Melrose Avenue, Santa Monica Boulevard and the Pacific Coast Highway in the early 1970s. He has discussed his actions in terms of an anthropologist, recording or preserving, creating a sort of 'time capsule' of the city (p.46). In 1973, following the model of *(Every Building on) The Sunset Strip*, he photographed the entire length of Hollywood Boulevard with a motorised camera. For a recent book, *Then and Now* (2005), he decided to photograph the same street, though this time he used colour film. The four parallel ribbons of photographs are placed horizontally across each spread. The experience of viewing the book is like a drive forwards and backwards in time. The passenger is led through a series of zones with different character: roadside driveways hinting at the wealth that lies behind, busy urban intersections, the centre of Hollywood (Grauman's – now Mann's – Chinese Theater, fig.79); past strip malls and eateries, gas stations, warehouses and car yards.

Metro Plots and Mountains

Perhaps as a result of looking through his photographic archive, in the mid-1990s Ruscha started working on a series of Metro Plots, pictures that take the street map of Los Angeles as their starting point, and abstract the city's grid into a barely recognisable sequence of dots, lines and faint text: 'They almost look like what these streets might look like in the year 5000 or something.' They also follow his long obsession with vistas composed of simple geometric shapes, long 'ribbons'

THEN & NOW 2005 (detail) [79]
142 gelatin silver prints in a wood box
69.9 x 100 (27 1/2 x 39 3/8)

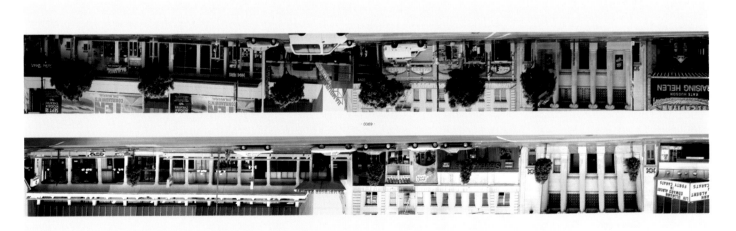

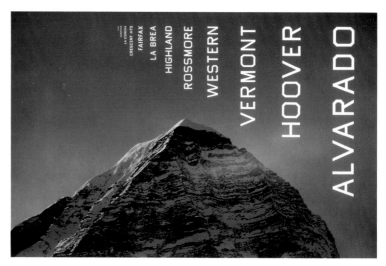

ALVARADO TO DOHENY 1998 [80]
Acrylic on canvas
177.8 x 274.3 (70 x 108)
Gallery Seomi, Seoul, Korea

and the urban aerial view, in particular City Lights like *Talk Radio* (p.83). He has recently started collecting aerial views of Los Angeles from the 1930s to the 1950s. Another source can be found in a studio notebook of March 1974, in which he sketched a diagram of 'My Drive Home to Laurel Canyon', demonstrating the twists, loops and turns of the route.[83]

The paintings, drawings and prints of this series are speckled shades of murky blue or yellow-grey, like soupy Los Angeles smog or the grain of tarmac – they are, as Ruscha puts it, pictures 'that look like the inside of your oven'.[84] The painting of the convergence of the Hollywood thoroughfares of *Santa Monica, Melrose, Beverly, La Brea, Fairfax* 1998 (fig.81) is a haze of fading lines and words, which is hard to decipher – it has to be 'read' like an unfamiliar map.

Ruscha had been incorporating street names into his work for many years, making early drawings *3327 Division Street* 1962 (his first studio) and *US 66* 1960, and a street sign photograph, *Sunset & Alvarado, Market Sign* 1960 (p.13). Although his artist's books don't contain much text, they do offer identifying 'facts'. *Some Los Angeles Apartments* and *Real Estate Opportunities* caption the photographs with numbers and street names: '818 Doheny Drive'; '3rd & Pico (southwest corner), Santa Monica'; *Every Building on the Sunset Strip* labels house numbers and marks the names of the streets that bisect the strip (Harper, Roxbury, Sweetzer); *A Few Palm Trees* gives the original locations of the plants, even though they are presented cut-out, in white space, and removed from their background ('Located at Hollywood Blvd. & La Brea Ave'). All these read like the titles of the Metro Plots.

Ruscha also painted Los Angeles street names on to dramatic mountainscapes. *Alvarado to Doheny* 1998 (fig.80) is a 'Metro Plot' with a typically incongruous backdrop, a deep blue snow-capped mountain, perhaps

Everest, dappled with sunshine. Dislodged from their original context in the map, the streets lose their meaning; we notice just the odd names of the words, the patterns in the lettering, and begin wondering whether they might relate to something else altogether (*Hope, Olive, Spring* 1999). The contrast between the thirteen street names and the imposing peak couldn't be more pronounced: untamed nature versus the planned modern city.

The mountain would become Ruscha's most consistent motif in paintings of the late 1990s and 2000s. As imagery from nature, it clearly recalls his Grand Horizontal paintings of the 1970s, but is substantially developed in that these mountains are so dramatic and so specific – his most 'scene stealing' surround yet. No longer simply 'supporting the drama of words', they compete with them. Like his Silhouette paintings, the mountains are archetypes, taken from picture-postcard views, books on the Himalayas and imagined 'ideas' of mountains. The peaks could be the Rockies or fictional ideals like the Paramount mountain peak or the Disney matterhorn in Anaheim. Despite the drama, one senses that it is the text, not the peak, that is the point: 'they're not really mountains in the sense that a naturalist would paint a picture of a mountain. They're ideas of mountains, picturing some kind of unobtainable bliss or glory ... tall, dangerous and beautiful.'[85] The power of such imagery means that it is often used in advertising, for merchant banks or life insurance.

A number of variations on the mountain backdrop 'support' different types of information or wordplay. The surreal *Darlene Phipps* 2002 has an intriguing text inscribed on the floor of the valley: 'Darlene Phipps / Wrks. at a Plastics Salvage Yard in Rosemead, CA.'. We presume she does, and smile at the disjunction between the grandeur of the mountain and her

SANTA MONICA, MELROSE, BEVERLY,
LA BREA, FAIRFAX 1998 [81]
Acrylic on canvas
1952 x 285 (60 x 112)
Los Angeles County Museum of Art

LION IN OIL 2002 [82]
Acrylic on canvas
162.6 x 183 (64 x 72)
Private collection

distinctly un-glamorous job. In a similar environment, Ruscha commemorates *Clarence Jones 1906–1987 / Really Knew How to Sharpen Knives* (fig.83). Rather disappointingly, these works do not represent real encounters, but fictional characters from dreams, representing 'anonymous people who don't exist, but exist in many people's lives' – workers who might inhabit the industrial spaces of his Blue Collar series (see below). Almost in a reversal of this idea, Ruscha said: 'I find that snow-capped mountains and aerial road maps are mundane enough to glorify in paint.'

Ruscha developed the mountain motif playfully. Some appear on 'shaped' canvases that swell and bulge at the edges (*Swollen Tune* 1998). Others display virtuoso wordplay: *Tulsa Slut*; *Sex at Noon Taxes*; *Never Odd or Even*; *Solo Gigolos*; *Step on no Pets*; *Don't Nod*; *Level as a Level*. The palindrome *Lion in Oil* 2002 (the picture is in fact painted in acrylic) is placed over a mountain that is itself mirrored down the middle line, a Rorschach test of sorts (fig.82).

Having revisited his photographic archive earlier in the decade, as the mid 2000s approached, Ruscha set his attention to revisiting his paintings. Like *17th Century* and *20th Century*, the comparison of a particular location across a period of time was also the basis for several sets of canvases. The first was Ruscha's *Course of Empire* 2005, created for the 2005 Venice Biennale. For this, his series of Blue Collar Paintings 1992–3, five black-and-white 'industrial' landscapes were presented alongside five new works that are set further into the future, 'revisiting' in colour these (fictional) locations. The title of the new series recalls a cycle of works by the nineteenth-century American landscape painter Thomas Cole (for a description of Ruscha's series, see pp.106–9).

Shortly afterwards Ruscha re-presented the canvas *A Particular Kind of Heaven* 1983/2005 for the newly rebuilt de Young museum in San Francisco's Golden Gate Park. In the original work in the de Young collection (the central panel), the title's phrase floats in a yellow and blue sky above a watery horizon. To rework the piece, Ruscha created two new canvases with the same dimensions, and installed them on either side of the original, matching the low horizon line of the three paintings together. The first and last letters of the text are repeated, like the mismatched panorama of an amateur photographer or the collage of pictures in (*Every Building on*) *The Sunset Strip* (p.47). Recalling works such as *Pr-Pr-Process Food*, the repeated lettering of the transformed phrase, 'A-a Particular-ar Ki-Kind of Heaven' suggests stuttering. The addition of a painted plank of wood, which appears to be propping up the sky in the panels, gives the picture a host of new connotations: the 'kind of heaven' depicted now seems as if it might be artificial, like a constructed movie set.

In an exhibition at London's Gagosian Gallery in 2008 Ruscha showed a series of diptychs that explored the theme of 'Then and Now' still further. ('The idea of ageing, it's not a sensitive issue to me. It's a total reality: everything falls apart. Maybe that's what I'm saying in these paintings.')[86] In *Untitled Diptych* 2007–8 and *Higher Standards/Lower Prices* 2007 the picture-postcard views of his mountain paintings now appeared to be marred by the encroachment of elements of industrial architecture ('I'm suggesting that the landscape is ruined by our forward motion in the world'). For the show, Ruscha also revisited two of his Grand Horizontal paintings. *Plank* 1979, a picture of a simple plank of wood, was paired with the monochrome *Plank in Decline* 2007, showing the same piece of timber warped, cracked and weather-beaten.

The vivid sky of *The Nineties* 1980 became a shade of dirty grey in its new partner *The 2000s* 2007, recalling the mood of his Silhouette works of the 1990s. ('I saw a lot of my paintings I did using an air gun as silhouettes of animals and automobiles that were very much like the Los Angeles landscape which was basically smog … this is like an extension of smog.')

The striking diptych *Azteca / Azteca in Decline* 2007 (fig.84) reintroduced the diagonal composition Ruscha had used in canvases such as *Large Trademark with Eight Spotlights* or *Picture Without Words*. The work appears to be collaged together from individual sheets of paper like a billboard – all skillfully rendered in trompe l'oeil. Based on a mysterious motif he had seen on a wall as he was driving to visit the ancient ruins of Teotihuacán, outside Mexico City, Ruscha imagined the red, green and blue rays – an entirely new palette for him – as representing 'some ancient or Aztec empire, like Montezuma's or something, from ancient Mexico, which goes through its cycles of life, and ends up like this.' In the second painting, the crumpled fronds have fallen to the ground, while the collaged sheets of paper seem to be peeling off the surface of the canvas, torn and stained.

In these works, Ruscha's longstanding theme of the depiction of objects being smashed, broken or damaged takes on a wider meaning, now extended to represent a wider cycle of destruction and decay; the course of empire.

During the 1990s and 2000s, then, Ruscha's position in the art world was consolidated. During retrospectives at the Hirschhorn Museum and Sculpture Garden in 2000 (travelling to Chicago, Miami, Fort Worth, Modern Art Oxford and Kunstmuseum Wolfsburg), work began on a seven-volume catalogue raisonné of his paintings and another of his drawings. (In 2000 he was even made the subject of a song by David Stephenson of Rocket Gallery in London:'I want to take a plane and fly to LA / I want to hang out with Ed Ruscha / He makes pictures and words interplay / He puts cool into LA'.) In 2004, exhibitions at the Whitney in New York focused on the artist's photographic practice (*Ed Ruscha and Photography*) and presented the first museum retrospective of his drawings (*Cotton Puffs, Q-Tips, Smoke and Mirrors*). His selection as the US representative for the 2005 Venice Biennale was high profile and almost universally acclaimed. The same month, the journal *October* devoted an entire issue to the artist. It seemed that his patience, consistency, deep-rootedness in the city of Los Angeles and refusal to relocate to the art centre of New York had finally paid off.

AZTECA /AZTECA IN DECLINE 2007 [84]
Acrylic on canvas
122 x 838 (48 x 330) each
Broad Art Foundation

For the 2005 Venice Biennale, Ruscha decided to revisit his 'Blue Collar' paintings of 1992, depicting industrial buildings in non-descript locations. 'Those are my 'T' paintings – Telephone, Tires, Trade School, Tool and Die. It's like a vision of a modern world, a futuristic world, about what architecture and things are going to look like.'[87] The works share the muted palette, angular composition and moody sky of the Silhouette works of the previous decade. Here, words are incorporated as painted signs on the front faces of the buildings, the only distinguishing feature for these white industrial boxes. The blank units, serial like Minimalist boxes, seem to inhabit an urban wasteland where everything looks the same even when it is different.

When revisiting the works, Ruscha decided to pose the question – what would these buildings look like even further into the future? The new works are all painted in colour; as in *17th Century* and *20th Century* (pp.96–7), the shift from black and white represents a leap forward in time – perhaps reflecting a change that would have occurred in the Hollywood films of Ruscha's youth. In all cases, the buildings are no longer being put to industrial or manufacturing use. *The Old Tech-Chem Building* site is now occupied by 'Fat Boy', whose name suggests a burger eatery, situated under a blood-red sky; *The Old Tool & Die Building* stands empty, the building covered in Asian graffiti including a red and blue sign that could be a soft drinks brand; *The Old Trade School Building* sits dilapidated; *Site of a Former Telephone Booth* consists of a lamppost and sycamore tree; *Expansion of the Old Tires Building* seems to be an anonymous warehouse.

For Venice, Ruscha installed the two series of paintings in a separate 'room' of the American Pavilion; the building 'pairs' were not placed side-by-side; instead, one had to travel to the next room to complete the story. He gave the installation the new title *Course of Empire*, from a five-part series of paintings by the American landscape painter Thomas Cole (1801–48). Cole's own cycle, completed in 1836 for the library of his patron Luman Reed, was inspired by the artist's visit to the ruins of ancient Rome. The series, which depicts the life cycle of a city state, is a drama of rise and fall in five acts: pale pink sunrise over a savage wilderness; pastoral arcadia; a baroque city state groaning under the load of its classical architecture and opulent style; its sacking and burning; and, finally, desolation in a moonlit setting, where the ruined buildings lie overgrown with weeds – ready for the cycle to begin again. Cole's original plans for the installation also included sketches of three much smaller, horizontal panels that would depict sunrise, noon and sunset – with similar proportions to Ruscha's widescreen sunset paintings.

Cole's work is very much of its time, relating to contemporary religious and philosophical meditations on the danger of empire building, including texts like Gibbon's *Decline and Fall of the Roman Empire*. Ruscha's series is far more ambiguous. Although he has described it as 'airing my doubts about progress in the world',[88] it is not – as one might expect from the title – a straightforward comment on the decay of modern civilisation or the world post 9/11. But it does deal explicitly with the subject of the changing urban landscape, something that Ruscha has previously explored in photographs but not in painting.

MARY RICHARDS How did *Course of Empire* at the Venice Biennale come about?

ED RUSCHA I was fortunate to have an exhibition space that was more or less perfect for those paintings. I was motivated by knowing that they were going to go into that neo-Palladian pavilion. Somewhere along the line, this notion came to me about time-jumps, and revisiting older works. That's just part of my make-up, so it was natural that these ideas would come out somehow, like the idea of photographing streets over the years, and watching deterioration or progress – depending on how you choose to look at it. These paintings, in essence, embrace that idea of change over time: the *Course of Empire*. That thought went side by side with my discovery of these paintings by Thomas Cole that are part of the collection of the New York Historical Society. I've been there several times to see these paintings that depicted this vast change over maybe hundreds of years of a civilisation, how it goes through cycles, from a savage state, back to the savage state. I don't know exactly where my attempts fall within that; they're not savage to savage, but they somehow show the change in things.

MR Your series doesn't end with complete destruction, or anything quite as apocalyptic.

ER Not to complete destruction. It's my view of the world. And it might be slightly pessimistic, but even so, they're like exercises for me. I see the change in things even more now. It doesn't have to be civilisations or buildings, necessarily; it can be almost anything. I did a painting of a plank of wood that I want to revisit and update, to see the deterioration [*Plank* 1979 / *Plank in Decline* 2007]. I saw a pencil the other day on the table-top, and I recognised that pencil immediately. It was about three inches long, and I loved that pencil! I remember using it in 1961 to make some drawings, and I travelled with it when I first went to Europe. So revisiting that thing is a spark. I won't do anything with that pencil, per se, but I'm always reflecting on things that I once knew, and am now returning to.

MR You photograph the Sunset Strip regularly. I suppose that's part of the same idea?

ER Yes. I'm looking at it almost like an anthropologist, or a geologist. I'm as interested in some of the less obvious things. People look at the buildings and say, 'What was that building before?' Well, what about the sidewalk in front of it, the curb that surrounds it, and the embankments here and there? I'm trying to look at the whole picture. When I think of Sunset Boulevard, it sort of strikes a chord with me, so I continue visiting that site, and I've been photographing it for years. So who knows what'll happen there.

MR Were the *Course of Empire* paintings based on real buildings and locations? When I came over to the studio this morning, I was interested to see all the industrial buildings in the area. And then I suddenly saw a tree that reminded me of *Site of a Former Telephone Booth*. I was wondering if that painting was based on a real place?

ER Yes it is, and no it isn't. It's a jump in time. The original telephone painting [*Blue Collar Telephone*]

was of the top of a telephone booth, and these structures are fast disappearing, in England too. So in 2005 I pictured it as something that is becoming useless today. I depend on suggestions, little things that come to me out of the corner of my eye, for motivation. I saw these sycamore trees, right around the corner here, so it was based on that. This sycamore tree would be part of the answer to what the hell has happened to the telephone box. So that's really where it comes from. It comes from things local. I don't have to imagine off in space somewhere what my paintings are going to be like. So that and the cement lightpost were part of the picture. It's all an experiment, an exploratory venture. And that's the basis of it. And then, once that's sort of hammered out, then it's a question of actually crafting a picture.

MR Could you talk about the relationship of these works to the Thomas Cole paintings?

ER I felt an affinity with that man and his voyage, or his experience, with his life as an artist. And I just felt that it paralleled mine, so that's why I even used his title. He lived a totally different life from me, of course. His life was one without modern conveniences. He painted those works in 1830, when life was, by our standards, primitive. And there was a whole set of different principles. I'm somebody who's influenced by the speed of modern life, whereas he was more influenced by the allegorical application of these notions that he had experienced. But I just thought it was such a powerful statement, with immense philosophical implications.

MR I'm interested in the choice of title, *Course of Empire*, in the light of America's place in the world at the moment. And also in the light of your earlier show in Venice in 1970, when people felt so strongly about Vietnam they wrote messages in the chocolate. I'm interested in the parallel between those ideas. Is that something that you thought about?

ER I don't see a logical connection between those two things. The only connection is that it happened to be the same artist doing both things. That earlier one – that chocolate room – grew out of some things I was doing in London at the time. I was at the Alecto Editions Workshop, and I was making those organic prints. So the idea of organic substances and using that as a focal point spun out of that.

MR Are artists like Cole or, perhaps, Edwin Church, a big influence on your landscapes and skies generally? I'm thinking, for example, of the colour of your sunsets?

ER I think so. Those painters – the Hudson River School – their images came to me through reproductions. I never really sought those paintings out, or stood before them and looked at the paint techniques or anything. It was like instant energy to me. People have asked me before about my connection with other artists – like René Magritte. I was of course alert to all his work, but somehow it's a backdoor influence. The world is so loaded with all kinds of images – photographic, painted, whatever – and the inspiration comes not so much from specific sources, but in general. I'm influenced by almost

everything I've ever seen. But specific influences are there also. The idea of landscapes and settings suns, and things like that, has something to do with where I was born and where I was raised, and travelling to California – you know, the highway; and something to do with the idea of the horizontal plane. Black-and-white photography for some reason has a strong place in my work as well. If I look at the entire movement of the Hudson River School and those naturalistic painters, I tend to want to yawn a little bit. But Thomas Cole I find quite intriguing. Although he's definitely from a different century!

BLUE COLLAR TELEPHONE 1992 [85]
Acrylic on canvas
137.5 x 305.1 (54 1/8 x 120 1/8)
Deutsches Postmuseum, Frankfurt

BLUE COLLAR TOOL & DIE 1992 [86]
Acrylic on canvas
132.1 x 294.6 (52 x 116)
Belgacom Foundation, Brussels

BLUE COLLAR TECH-CHEM 1992 [87]
Acrylic on canvas
123.5 x 277.8 (48 5/8 x 109 3/8)
Broad Art Foundation

SITE OF A FORMER TELEPHONE BOOTH 2005 [88]
Acrylic on canvas
137.5 x 305.1 (54 1/8 x 120)
Private collection

THE OLD TOOL & DIE BUILDING 2004 [89]
Acrylic on canvas
132.1 x 294.6 (52 x 116)
Private collection

THE OLD TECH-CHEM BUILDING 2003 [90]
Acrylic on canvas
123.5 x 278.1 (48 1/2 x 109 3/8)
Broad Art Foundation

TELEPHONE

TOOL & DIE

TECH-CHEM

'HOLLYWOOD IS A VERB': ED RUSCHA AND CINEMA

I see things as a moving, panoramic landscape, maybe in the same way you might see a movie. It also reflects back on the way words are printed on a page in succession. Words and characters are really landscapes and they're as panoramic as you want to make them.[89]

'Hollywood' is like a verb to me. It's something that you can do to any subject or any thing. You can take something in Grand Rapids, Michigan and 'Hollywoodize' it. They do it with automobiles, they do it with everything that we manufacture.[90]

On 28 December 1895, in the basement of the Grand Café on Boulevard des Capucines, Paris, the Lumière Brothers screened *L'Arrivee d'un Train en Gare de la Ciotat*, a *cinèmatograph* projection of a steam train coming into the station at the French coastal town of La Ciotat. Cinema legend has it that members of the audience were so terrified that some of them ran from the screen to avoid the locomotive they thought was hurtling towards them. Such descriptions of the naivety of early spectators may be mythical, but the shot, which positioned the eye of the spectator down by the side of the tracks, was so powerful that it has been emulated by cinematographers many times since. Ruscha remembers similar images from films of his youth:

It seemed all movies would have a train in them. Invariably, they had the camera down on the tracks and shot this train so it appeared as though it was coming from nowhere, from a little point in the distance, to suddenly zooming in and filling your total range of vision. In a sense, that's what the Standard gas station is doing. It's super drama.[91]

Recent books have explored Ruscha's relationship with the photographic image, but it can also be argued that he 'sees' cinematically. This is manifested in the way he often 'Hollywoodises' his subjects, be they words or images, by seeming to 'shoot' them from particular angles, or 'light' them in certain ways in order to enhance their dramatic potential. As well as referencing the cinematography found in narrative films, Ruscha's word works feature flat text against an abstract sky or landscape ground, in the same way that text and image co-exist on the cinema screen during title-credit sequences. He also makes direct references to cinema in his work, quoting specific titles and fragments of dialogue, as well as painting the screen, the projected light beam and the 'scratches on the film'.

Hal Foster has described Ruscha's art as the 'combination of the automobile, the storefront, the billboard and the cinema'.[92] All of these elements imply mobility – the driver looking out through the windscreen at graphic signs on the highway, the flâneur cruising shopping malls and taking in window displays, and the spectator of the moving image in the theatre. As a painter, Ruscha creates static rather than moving images, though his canvases *Standard Station* 1966 (pp.24–5) and *Large Trademark with Eight Spotlights* 1963 (p.23) both share the drama of the Lumière Brothers' train; the former evokes the speed of an automobile travelling down the highway; the latter heightens the grandeur of the already monumental Fox logo (one can almost hear its fanfare signature tune playing in the background). Ruscha has noted that once he had settled on the composition of these paintings, he began to see everything – even a loaf of bread – from the same perspective (see the drawing *Wonder Bread* 1963). Dividing the canvas in this manner would continue to preoccupy him. In the same way that he would repeatedly use particular motifs, he would also frequently depict subjects from this 'low-angle': the moving wagons of *Uncertain Frontier* (p.87), the suburban houses of *Name, Address,*

THE BACK OF HOLLYWOOD 1976–7 [91]
Acrylic-vinyl on canvas
c. 4.88 x 15.24 m (c.16 x 50 feet)

Phone (p.89), and paintings of actual cinema screens such as *The Long Wait* (fig.103).

One can find other 'shots' in Ruscha's armoury. The aerial perspective of *Los Angeles County Museum on Fire* (pp.62–3)was once described as a 'crane shot' by critic Peter Plagens, who likened it to the view of the Atlanta Railroad in *Gone With the Wind*. This view can also be found in Ruscha's 'ribbon' words, such as *OKLA.* (p.54), and in the depictions of nocturnal and abstracted city streets in his City Lights and Metro Plots (pp.83, 98). His book *(Every Building on) The Sunset Strip,* created by attaching a camera to a moving vehicle and shooting in real time, might best be described as a two-mile-long 'tracking shot', while his similarly panoramic Grand Horizontals echo the immersive vistas of widescreen films. The language of cinema is also evident in the soft focus of his delicate *Los Angeles Apartments* drawings and the silhouetted shapes of the Nocturnes series. In the latter, he appears to employ the tools of classic 1940s and 50s film noir: high-contrast lighting, deep shadows and scenes in moonlit darkness produce psychologically charged imagery. *Caribe* 1989, a house in darkness, seems to be composed from the perspective of a noir detective approaching to investigate a murder scene inside; in *Fistful of Aliens* 1986, the title a reference to the Spaghetti Western *A Fistful of Dollars*, cacti and Joshua trees loom menacingly, silhouetted against a misty sky.

Ruscha has even 'Hollywoodised' the Hollywood sign, that universal symbol of the glitz and glamour of the movie industry, by placing the letters of the Los Angeles landmark on the crest of a mountain rather than picturing them in their actual location halfway up Mount Lee. The letters of the screenprint *Hollywood* 1968 (fig.92) are rendered in the same dramatic perspective as *Large Trademark with Eight Spotlights,*

receding into the space of the middle distance. The scene is illuminated by an intense orange and gold sunset, perhaps symbolising the studios' promise of stardom.

Film-makers began coming to Hollywood in the early 1900s. Though the village was merely a collection of *Barns and Farms* (the title of a 1983 Ruscha painting), the location presented near-perfect conditions for movie-making: excellent natural light, at least 300 days of sunshine a year, and a wide range of locations in the vicinity – mountains and desert, farms and villages, the coast and the ocean, and, of course, the growing city of Los Angeles. Paramount was the first major studio to commission a picture: director Cecil B. DeMille leased a barn on the corner of Vine and Selma in 1913 to film *The Squaw Man*. By the 1920s, the major studios were all established, many of them situated within a few blocks of each other in the region between Hollywood and Beverly Boulevards. To appreciate their rapid growth over subsequent decades, one only needs to look at Ruscha's aerial view of Universal's parking lot in his 1967 book *Thirtyfour Parking Lots* (p.36).

The Hollywood sign itself was erected in 1923, as a temporary structure spelling out 'Hollywoodland', a lavish advertisement for a real-estate development in the area. During the Depression, the fifty-foot high letters, made of painted wood and illuminated with some 4,000 lightbulbs, were neglected and left to decay on the hillside. The developers handed the dilapidated sign over to the city in the 1940s, at which time the letters spelling 'land' were removed and the word 'Hollywood' was repaired and reinstated. Ruscha recalls using the sign (which he could see from his Western Avenue studio window) as a weather indicator; on a clear day, he could make out the letters,

HOLLYWOOD 1968 [92]
Screenprint
44.5 x 112.9 (17 ½ x 44 ⁷⁄₁₆)

at other times the sign was clouded with smog. Perhaps partly because he looked at the words every day, perhaps due to the sign's visual appeal, he pictured it in various configurations. The 'sunset' view of the 1968 screenprint became *The Back of Hollywood* 1976–7 (fig.91), created as part of a public-art commission. Made from a large sheet of sateen, a flexible material used for billboards, the picture advertised 'Hollywood' just as the original letters of the sign had promoted 'Hollywoodland'. *The Back of Hollywood* was situated on a corner of Wilshire Boulevard opposite the Los Angeles County Museum of Art; the text was painted in reverse, and could therefore only be read by the mobile spectator, who would catch sight of it in the rear-view mirror of a car. The idea of a 'rear view' points to the artifice of the image of 'Tinseltown', and also relates to Robert Frank's *The Back of the Hollywood Sign* 1955, a photograph detailing the hidden supports that prop up the 'H'. Ruscha has said, 'The idea of Hollywood has lots of meanings and one – to me – is this image of something fake up here being held up with sticks.'[93] In the same way, he relates the Sunset Strip, with its two-dimensional façade, to a movie set: 'It's like a Western town in a way. A storefront plane of a Western town is just paper, and everything behind it is just nothing.'[94] Ruscha's pastel on paper work *Another Hollywood Dream Bubble Popped* 1976 (fig.94) highlights the contrast between the hopes of newcomers to Hollywood and the disappointment of its reality. Little illustrates this subject better than the 1932 suicide of Broadway actor and movie hopeful Peg Entwistle, who plunged from the top of the 'H' of the Hollywood sign into the cactus below, later causing her death.

The year after Ruscha's billboard commission, a high-profile 'Save the Sign' campaign was launched, after the actual sign, now given Landmark status, had fallen into further disrepair. In a fundraiser hosted by Hugh Hefner at his Playboy mansion, letters were auctioned off at a price of $28,000 each (rock star Alice Cooper bought an 'O').

Ruscha's prints and drawings of the Hollywood sign, and his book (*Every Building on*) *The Sunset Strip*, would eventually lead to panoramic paintings, which he refers to as Grand Horizontals. Works such as *Thermometers Should Last Forever* 1977 are clearly influenced by the idea of widescreen cinema. The innovative film format of CinemaScope, created by Fox, was first seen in *The Robe* (1953), starring Richard Burton. The CinemaScope process involved filming with, and projecting back through, an anamorphic lens, on to a screen with an aspect ratio of 2.35:1 (the same dimensions as Ruscha's *Standard Station* and *Large Trademark with Eight Spotlights*). Other film studios followed with their own variations on the widescreen format; all were attempts to woo back audiences who were enjoying the convenience of television in their own homes.[95] The drop in cinema-ticket sales had been staggering – between 1948 and 1957, the weekly movie audience fell from 100 million to 40 million (the population at that time was 170 million).[96] The new widescreen format constituted a brief revival, and the young Ruscha would have experienced the visual impact of these widescreen formats. In 'Glorious Technicolor, Breathtaking CinemaScope', a 1959 lecture on the new technologies, Richard Hamilton remarked, 'The larger the screen the more convincing the impression of three-dimensional space; the more profound the engagement of the spectator with the action.'[97] The extra screen width was not suitable for close-ups of stars' faces, but for spectacular vistas, evoking dramatic crowds and

ORANGES, PEACHES, PEARS, APPLES,
GRAPES, YOU NAME IT 1977 [93]
Oil on canvas
55.9 x 203.2 (20 x 80)
Private collection

ANOTHER HOLLYWOOD DREAM BUBBLE POPPED

A BLVD. CALLED SUNSET

battles, and equally, silence, isolation and distance. Just as the panorama contributed to the audience's immersion in the picture, narrowing the distance between the spectator and the image, Ruscha's Grand Horizontals, broader in aspect ratio even than wide-screen film, fill our field of vision.

A lot of my paintings are anonymous backdrops for the drama of words. In a way they're words in front of the old Paramount mountain.[98]

Ruscha's works could be compared to the title sequences of movies: words and images occur in the same visual field; logos and credits are floated against a backdrop of generic grounds or skies. The same year he made *Large Trademark with Eight Spotlights*, he also painted the Paramount logo. In this famous piece of design, still used today, the word 'Paramount' hovers in front of a mountain peak high up in the clouds, crowned with a halo of stars. Though the painting he created was destroyed, Ruscha would later return to the imagery it contained: cloudy skies, the motif of the mountain, and the ring of words. Perhaps by accident rather than design, he would also use imagery from other studios' logos: globes floating in space (Universal); the curve of the Earth's edge (RKO, the only major studio of Hollywood's heyday that has not survived to the present day); beams of light bearing down through clouds (Columbia) and 'ribbons' of film (Metro Goldwyn Mayer). The job of the film studio logo is to communicate grandeur, and the imagery they select is fitting for this purpose; this relates to Ruscha's comment that he is painting 'ideas' of mountains rather than the mountains themselves.

In addition to his 'cinematic' techniques and direct references to the imagery of film, the text in Ruscha's work is often culled from film titles or fragments of dialogue. Many examples are included in this chapter.

The working title of *(Every Building on) The Sunset Strip* was 'Sunset Boulevard', though he eventually settled for the more literal description. *A Blvd. Called Sunset* 1975 (fig.95), made with blackberry juice on moiré, also references the film *Sunset Blvd.* (and includes the abbreviation that was used in the film's title). Such text works bear a resemblance to the cards of dialogue used between the moving pictures in the silent movies. Other works quote dialogue from sound films: *I Told You Nobody Ought Never to Fight Him* 1998, rendered in white, block letters that are superimposed over a mountain peak, is a quotation from the 1939 film of John Steinbeck's *Of Mice and Men*. *Brave Men Run in My Family*, a phrase used in several drawings and paintings, is taken from the Bob Hope Western *Son of Paleface* (1952) – the example shown here (fig.96) includes the motif of a camera that looks rather like a movie alien (perhaps the thing from which the 'brave men' are running).

'Scratches on the Film'

I always found those leaders on a film that would say, '9, 8, 7, 6, 5 …' quite beautiful. Fifty years from now, there isn't going to be such a thing as scratches on films. They're just not going to exist. So you're going to look at something like that and say, 'What does that mean? What are those vertical scratches in there?' All I'm doing is illustrating a phenomenon that's going to be linked to a certain spot in history.[99]

Ruscha's 1974 text work *Scratches on the Film* (shellac on satin) pointed to his interest in – and, perhaps, nostalgia for – the material of celluloid, which like vinyl is gradually dying out in the digital age. In the 1990s, perhaps in reference to this, he created a series of works depicting cinema screens, paying particular attention to the pops, tears and crackles

ANOTHER HOLLYWOOD
DREAM BUBBLE 1976 [94]
Pastel on paper
58.7 x 74 (23 ⅛ x 29 ⅛)
Private collection

A BLVD. CALLED SUNSET 1975 [95]
Blackberry juice on moiré
71.1 x 101.6 (28 x 40)
Museum Ludwig, Cologne

BRAVE MAN'S CAMERA 1996 [96]
Acrylic on paper
152.4 x 97.2 (60 ⅛ x 38 ⅛)
The Getty Trust

which have shown up in the magnified, projected image. The black-and-white palette and the vertical lines and dots that sit on the surface of *Western* 1991 (fig.97), a painting of a teepee in soft focus, give the picture a weathered charm, and also point out that such genres now belong in the pages of history books. Titles of others in the series also recalled the Western (*Apache*), the idea of a golden era of cinema (*Triumph*) or specific films: *Asphalt Jungle* is also a reference to the title of the classic 1950 film noir by John Huston.

Ruscha created the same artificially weathered effect in a series of 1990s prints remade from the photographs of *(Every Building on) The Sunset Strip*. These were created by taking a razor blade to enlarged duplicate negatives, tearing and scratching the surface before having them printed up (the legendary *Schwab's Pharmacy*, p.94, also featured in the film *Sunset Blvd.*). He created a similar 'aging' in the print series *Cameo Cuts*, by drawing directly onto the stones with lithographic crayons and razor blades.

Just as Ruscha is interested in the 'object' quality of words, these works show a fascination for the material aspects of cinema. The idea of 'scratches on the film' recalls 1960s works by experimental film-makers such as Stan Brakhage and Bruce Conner, whose scratched, painted and collaged negatives created extraordinary visual effects. They also remind the viewer that cinema is a physical process, the projection of a piece of film through a light source onto a screen; these works radically shifted the boundaries of film by drawing attention to process in the same way that Abstract Expressionist painters made the act of painting the subject of their work. The 'premeditated' blemishes of Ruscha's canvases and prints of cinema screens – like his 'spilled' words – are reminiscent of Pollock's drips; they also reference the accidental 'tears' on the surfaces of Warhol's silkscreen paintings, irregularities caused the process of their making. In an essay on Warhol, Hal Foster compared these 'pops' to what Roland Barthes termed the 'punctum', the element in a photograph that makes the reader aware of the act of viewing; such surface 'mistakes' jump the reader out of the picture.[100] This 'jump' is also found in Orson Welles's *Citizen Kane*, described by Kerry Brougher in the catalogue to *Art and Film Since 1945: Hall of Mirrors*:

Following 'News on the March', a newsreel documentary focusing on Kane's life, we cut to the bright light of a film projector, are presented with the illuminated words 'The End' seen at an angle from within the cramped, dark space of a screening room and hear the optical track grind to a halt ... The shift is startling, the film within a film suddenly disrupting our suspended disbelief.[101]

Like Edward Hopper's *New York Movie*, where our attention is drawn not to the screen but to the figure of a woman standing by the stairwell, Ruscha also depicts other peripheral or overlooked aspects of the cinema. *9,8,7,6* 1991 (fig.102) is one of many works that focuses on the leaders that supply the countdown before the film begins. The unlikely star of Ruscha's *Exit* 1990 (fig.98) is a 'way-out' sign, situated to the right of the blank screen. This work resembles Hiroshi Sugimoto's photographs of movie theatres from the 1920s and 30s, and 1950s drive-ins (1976–). To create these luminous screens, Sugimoto used a large-format camera and a long exposure that lasted the duration of the film: 'One night I had an idea while I was at the movies: to photograph the film itself. I tried to imagine photographing an entire feature film with my camera. I could already picture the projection screen making itself visible as a white rectangle. In my imagination, this would appear as a glowing, white rectangle; it would

WESTERN 1991 [97]
Acrylic on canvas
182.9 x 243.8 (72 x 96)
Private collection

EXIT 1990 [98]
Acrylic on canvas
157.5 x 228.6 (62 x 90)
Private collection

Hiroshi Sugimoto
STUDIO DRIVE-IN, CULVER CITY
1993 [99]
Photograph on paper
42.4 x 54.3 (16 $\frac{2}{3}$ x 21 $\frac{1}{3}$)

PICTURE WITHOUT WORDS 1997 [100]
Acrylic on canvas
701 x 360.7 (276 x 142)
The Getty Museum, Los Angeles

come forward from the projection surface and illuminate the entire theater. This idea struck me as being very interesting, mysterious, and even religious.'[102] In Sugimoto's pictures, the 'blank' screen in the centre leaves the viewer to concentrate on ornate backdrops, curtains or architecture rendered in intense detail. The interiors were built during the golden age of the cinema audience, a time when the architecture was individual as opposed to the facelessness of the multiplex. Sugimoto's drive-in pictures such as *Studio Drive-In, Culver City* 1993 (fig.99) document a time when theatre attendance was in decline and car ownership was rising sharply. In a project similar to Ruscha's recording of the streets of Los Angeles described in the last chapter, Sugimoto has been collecting these images for three decades; like Ruscha's photographic views, they are empty of human presence and are bestowed with a silent calm.

Ruscha's *The Long Wait* 1995 (fig.103), whose title is taken from the 1954 film noir based on a novel by Mickey Spillane, includes not just the cinema screen but also the projected light beam. This had first featured in *Large Trademark with Eight Spotlights*, and recurred in a series of 1975 *Miracle* drawings, pastels in which shafts of light bear down through cloudy, smoky skies (fig.101). Such effects have long been used to signal visions or appearances of heavenly bodies in religious paintings such as *Jacob's Dream* 1710/15 by one of Rembrandt's pupils, Arent De Gelder; in *The Wizard of Oz*, rays symbolising fresh hope shine through the storm-clouds after Judy Garland sings 'Over the Rainbow'. A link between cinema and religion might also be intended in *The Long Wait*: on the right is the screen, a picture within a picture, on which is written 'The End' in Gothic lettering – perhaps a reference to the Biblical 'in the beginning'.

Projected light is also the subject of the monumental *Picture Without Words* 1997 (fig.100), created for the entrance to the auditorium in the new Richard Meier-designed Getty Center in the Los Angeles hills ('that wall is a large piece of real estate', Ruscha wrote on a sheet of notes while brainstorming). In this nearly thirty-foot high vertical work, a shaft of light emanating from the top corner of the canvas projects a sharp white rectangle to the bottom left. The angle is such that the pool of light is not fully contained within the confines of the canvas, and the picture's edginess stems from the composition being slightly off-kilter ('it didn't work when I made it scientifically correct'). The painting was installed in a space surrounded by windows that cast similar shapes on to the floor during certain times of day, creating a world within a world. In the picture, the beam could equally be illuminating a Cathedral or a prison cell, and is intensely cinematic. It bears a striking resemblance to a scene in *Citizen Kane*, where Kane enters the dark space of the Thatcher Library seeking illumination on the history of his benefactor. Ironically, the canvas was painted horizontally and shown vertically; and if turned on its side, *Picture Without Words* could be one of Ruscha's paintings of cinema projections – perhaps in this sense the 'picture' of the title refers to the movies.

While the composition of many of Ruscha's paintings can be seen to relate to Hollywood cinema, the imagery found in his photographic books bears a closer relation to avant-garde film. In their use of mundane, serial subjects, the books can be compared to Andy Warhol's early films, similarly deeply inspired by Duchamp. The year Ruscha made *Twentysix Gasoline Stations*, Warhol shot his first film, *Sleep*, five hours of footage of his friend, the poet John Giorno, sleeping in the Factory. Further 'single-shot' films followed, in

MIRACLE #64 1975 [101]
Zinc oxide and pastel on paper
98.1 x 74.3 (38 5/8 x 29 1/4)
Tate and the National Galleries of Scotland. Acquired jointly through The d'Offay Donation with assistance from the National Heritage Memorial Fund and The Art Fund 2008

9, 8, 7, 6 1991 [102]
Acrylic on canvas
71.1 x 107 (28 x 42 1/8)
Private collection

which Warhol simply picked a subject and left his Bolex camera running. The eight-hour long *Empire* is possibly the best example of this meticulous attention to a single image, in this case the Empire State Building, filmed from the forty-first floor of the Time-Life building as night fell on 25 July 1964. (Ruscha has said that he also toyed with the idea of taking a series of photographs of Standard Stations at night.) Unlike Warhol, who simply left the camera running, Ruscha carefully chose the collections of photographs in his books and then 'edited' them together; Reyner Banham has described Ruscha's editing as 'a selectivity akin to the editing of a movie'. 'Blankness' or absence of direction can also be found in Ruscha's books; photographs such as the *Los Angeles Apartments* series have a distinctly cinematic logic – these exterior views suggest that a drama might be taking place behind closed doors, inviting the viewer to project a narrative; similarly, one imagines a stick-up or a car chase ending at one of the *Twentysix Gasoline Stations*, a Hollywood suicide a la *Sunset Boulevard* at one of the *Nine Swimming Pools* (perhaps involving the Broken Glass), or maybe a murder mystery concerning *Real Estate Opportunities*.

One might have expected Ruscha's own films to follow the model of his books. However, *Premium* (1971) and *Miracle* (1975), both in colour, tell simple, playful stories. Recurring Ruscha imagery can be found in the films; yet, at a most basic level, their narratives are at odds with the logic of his works, where the relationship between groups of words, or juxtapositions of images and words, are unresolved. Ruscha has said, 'My paintings have more of a relation to movies than to painting', and that he is 'inspired by movies, because I think movies have the potential of becoming a more powerful art form than painting because movies can talk about so much, and paintings can't.'[103] On the other hand, he notes that films are involved in 'a different kind of art ... [Artists are] presenting things as problems to people and not explaining them as stories ... [filmmakers are] interested in the logical side of things, and we're interested in the things that clash, or are inexplicable.'[104]

Ruscha has spent his entire creative life in the world's filmmaking capital. Perhaps due to a sense of place or to a fascination with the movies, the idea of film has permeated his work in a number of ways. As we have seen, he uses 'cinematic' compositions to dramatise his pictures, and often layers abstract fields or images in the 'background' and text in the 'fore-ground' in the same way that movie titles combine these elements. He has quoted extensively from film imagery and dialogue. Yet despite his own forays into the world of film, he is a painter at heart and rarely strays far from canvas, paper or the printmaking studio; his 'cinematic' imagery is rendered in paint rather than on celluloid.

THE LONG WAIT 1995 [103]
Acrylic on canvas
127 x 284 (50 x 112)
Private collection

Notes

1 Howardena Pindell, 'Words with Ruscha' (1973), in Alexandra Schwartz (ed.), *Leave Any Information at the Signal: Writings, Interviews, Bits, Pages*, Cambridge, Mass. 2002, p.57.

2 Patricia Failing, 'Ruscha, Young Artist' (1982), Schwartz 2002, p.227.

3 Paul Karlstrom, 'Interview with Ruscha in his Hollywood Studio' (1980–1), Schwartz 2002, p.98.

4 Ibid., p.99.

5 Ibid., p.101.

6 Bernard Brunon, 'Interview with Edward Ruscha' (1985), Schwartz 2002, p.250.

7 Interview with the artist, 10–11 Oct. 2005.

8 See *Ferus*, exh. cat., Gagosian Gallery, New York 2005. Ferus later moved over the road to no.723.

9 1966 statement, Schwartz 2002, p.3.

10 Interview with the artist, 10–11 Oct. 2005.

11 Ibid.

12 Karlstrom interview, Schwartz 2002, p.114.

13 1977 statement, Schwartz 2002, p.11.

14 Karlstrom interview, Schwartz 2002, p.118.

15 'Nostalgia and New Editions: A Conversation with Ed Ruscha', Sylvia Wolf, *Ed Ruscha and Photography*, exh. cat., Whitney Museum of American Art, New York 2004, p.262.

16 Ibid., p.259.

17 Ibid., p.261.

18 Alexandra Schwartz, '"Second City": Ed Ruscha and the Reception of Los Angeles Pop', *October* 111, Winter 2005, pp.23–43.

19 *Catalogue Raisonné of the Paintings: Volume One: 1958–1970*, Göttingen and New York 2003, p.66.

20 Bonnie Clearwater, 'Interview with Ruscha' (1989), Schwartz 2002, p.290.

21 Brunon interview, Schwartz 2002, p.250.

22 Bernard Blistène, 'Conversation with Ed Ruscha' (1990), Schwartz 2002, p.301.

23 Willoughby Sharp, 'A Kind of Huh' (1973), Schwartz 2002, p.65.

24 John Coplans, 'Concerning *Various Small Fires*: Edward Ruscha Discusses His Perplexing Publications' (1965), Schwartz 2002, pp.23–7.

25 Elizabeth Armstrong, 'Interview with Ruscha' (1994), Schwartz 2002, p.330.

26 Sol LeWitt, 'Paragraphs on Conceptual Art', *Artforum*, vol.5, no.10, Summer 1967, pp.79–83.

27 Lucy Lippard, *Six Years: The Dematerialization of the Art Object* (1973), revd. edn., California 2001, pp.vii–xv.

28 Douglas M. Davis, 'From Common Scenes, Mr Ruscha Evokes Art' (1969), Schwartz 2002, p.28.

29 Pindell interview, Schwartz 2002, p.63.

30 Interview with Sarah Greenberg, *RA Magazine*, Summer 2005.

31 Karlstrom interview, Schwartz 2002, p.129.

32 Reyner Banham, *Los Angeles: The Architecture of Four Ecologies*, California 2001, p.157.

33 Henri Man Barendse, 'Ruscha: An Interview' (1981), Schwartz 2002, p.215.

34 David Bourdon, 'Ruscha as Publisher' (1972), Schwartz 2002, p.43.

35 Cecile Whiting, *Pop LA: Art and the City*, California 2005.

36 Ibid, p.170.

37 Douglas M. Davis, From Common Scenes, Mr Ruscha Evokes Art' (1969), Schwartz 2002, p.29.

38 Bourdon interview, Schwartz 2002, p.44.

39 See Dan Graham, 'Homes for America', *Arts Magazine*, New York, Dec. 1966–Jan. 1967.

40 Interview with the artist, 10–11 Oct. 2005.

41 Paul Ruscha, *Paul Ruscha's Full Moon*, Gottingen 2006, p.181.

42 Claes Oldenburg, 'I Am for an Art' (1961), in Charles Harrison and Paul Wood (eds.), *Art in Theory 1900–1990*, revd. edn., Oxford 1993, pp.745–6.

43 Ed Ruscha, *Mountains and Highways*, exh. cat., Anthony d'Offay, London 2000.

44 Clive Phillpot, 'Sixteen Books and Then Some', in Siri Engberg (ed.), *Edward Ruscha: Editions 1959–1999*, exh. cat., Walker Art Center, Minneapolis 1999, p.67.

45 Wolf 2004, p.266.

46 Georges Perec, 'The Street' (1974), in *Species of Spaces and Other Places*, London 1999, pp.46–56. See ibid., pp.244–9 for 'Attempt at an Inventory…'.

47 Interview with the artist, 10–11 Oct. 2005.

48 Robert Venturi, Denise Scott Brown, Steven Izenour, *Learning From Las Vegas: The Forgotten Symblism of Architectural Form* (1972), revd. edn., Cambridge, Mass. 1977, pp.8–9

49 Ibid., p.35.

50 Transcription of the film by Gary Conklin, *L.A. Suggested by the Art of Ed Ruscha* (1981), Schwartz 2002, p.223–4.

51 'Conversation Between Walter Hopps and Edward Ruscha' (1992), Schwartz 2002, p.320.

52 Failing interview, Schwartz 2002, p.231.

53 Pindell interview, Schwartz 2002, p.57.

54 Vladimir Nabokov, *Speak Memory* (1951), Harmondsworth 2000, p.29.

55 Greenberg 2005.

56 Yve-Alain Bois, 'Thermometers Should Last Forever', reproduced in *October* 111, Winter 2005, pp.60–80.

57 Ibid., p.78.

58 Karlstrom interview, Schwartz 2002, p.151.

59 Fred Fehlau, 'Ed Ruscha' (1988), Schwartz 2002, p.265.

60 Dave Hickey, 'Available Light', *The Works of Edward Ruscha*, exh. cat., San Francisco Museum of Modern Art, San Francisco 1982, p.22.

61 Rosalind Krauss, 'Washington', *Artforum*, May 1971, p.85; quoted in Bois 2005, p.68.

62 Interview with the artist, 10–11 Oct. 2005.

63 Bourdon interview, Schwartz 2002, pp.43–5.

64 Interview with the artist, 10–11 Oct. 2005.

65 Ibid.

66 Failing interview, Schwartz 2002, p.236.

67 Christopher Fox, 'Ruscha Discusses His Latest Works' (1970), Schwartz 2002, p.32.

68 Ibid., pp.31–2.

69 Ibid.

70 Bickers interview, *Art Monthly*, Dec. 2001–Jan. 2002.

71 Wolf 2004, p.268.

72 Bourdon interview, Schwartz 2002, p.40.

73 Transcription of *L.A. Suggested by the Art of Ed Ruscha* (1981), Schwartz 2002, p.220.

74 Neville Wakefield, *Material Fictions and Highway Codes*, exh. cat., Anthony d'Offay, London 1997, pp.23–31.

75 Richard Prince, 'Ed Ruscha: The Original Master of California Cool Has Never Been Hotter', *Interview*, July 2005.

76 'Hollywood Decks the Halls: Ed Ruscha' (1996), Schwartz 2002, p.341.

77 Raymond Chandler, *The Big Sleep* (1939), London 2005, p.43.

78 Fehlau interview, Schwartz 2002, p.266.

79 Ibid.

80 Steven Rosen, 'Panoramic Art at Library Elusive But Impressive' (1995), Schwartz 2002, p.337.

81 Samuel Taylor Coleridge, *Table Talk*, 12 July 1827.

82 Paul Karlstrom, 'A Conversation with Ed Ruscha', *Fine Arts*, Fall/Winter 2005–6, San Francisco 2006, pp.34–5.

83 *Catalogue Raisonné of the Paintings, Volume Two: 1971–1982*, Göttingen and New York 2005, p.177.

84 Michael Duncan, 'The Return of a Native Son' (1998), Schwartz 2002, p.343.

85 Ed Ruscha in *Mountains and Metro Plots*, exh. cat., Gagosian Gallery, 1999.

86 All quotations from Ben Luke, 'Ed Ruscha: The Art of Falling Apart', *Art World*, no.4, April/May 2008, pp.130–5.

87 Hopps interview, Schwartz 2002, p.327.

88 Greenberg 2005.

89 Ibid.

90 Transcription of *L.A. Suggested by the Art of Ed Ruscha* (1981), Schwartz 2002, p.220.

91 Wolf 2004, pp.264–5.

92 Hal Foster, 'Survey', *Pop Art*, London 2005, p.35.

93 Transcription of *L.A. Suggested by the Art of Ed Ruscha* (1981), Schwartz 2002, p.220.

94 Bourdon interview, Schwartz 2002, p.43.

95 See Richard Hamilton, 'Glorious Technicolor, Breathtaking CinemaScope and Stereophonic Sound', in *Collected Words 1953–1992*, London 1982, pp.112–31.

96 David Thomson, *The Whole Equation*, London 2006, p.317.

97 Hamilton 1982, p.114.

98 Margit Rowell, *Cotton Puffs, Q-Tips, Smoke and Mirrors: The Drawings of Ed Ruscha*, exh. cat., The Whitney Museum of American Art, New York 2004, p.21.

99 Interview with the artist, 10–11 Oct. 2005.

100 Hal Foster, 'Trace and Reference in Early Warhol', *The Return of the Real*, Cambridge, Mass. 1999.

101 Kerry Brougher, *Hall of Mirrors: Art and Film Since 1945*, exh. cat., Museum of Contemporary Art, Los Angeles 1995, p.27.

102 Thomas Kellein, *Hiroshi Sugimoto: Time Exposed*, London 1995, p.91.

103 Lewis MacAdams, 'Catching up with Ed Ruscha' (1982), Schwartz 2002, p.241.

104 Karlstrom interview, Schwartz 2002 p.166.

Biography

Born in 1937 in Omaha, Nebraska
Lives and works in Los Angeles

Selected Solo Exhibitions

1963 Ferus Gallery, Los Angeles
1964 Ferus Gallery, Los Angeles
1965 Ferus Gallery, Los Angeles
1967 *Gunpowder Drawings*, Alexander Iolas
Gallery, New York
1968 Irving Blum Gallery, Los Angeles
Galerie Rudolf Zwirner, Cologne
1969 *Edward Ruscha: New Graphics*, Multiples,
Inc., Los Angeles
Irving Blum Gallery, Los Angeles
La Jolla Museum of Art, California
1970 Alexander Iolas Gallery, New York
Books by Edward Ruscha, Galerie Heiner
Friedrich, Munich
*Edward Ruscha: Prints 1966–1970/ Books
1962–1970*, Hansen Fuller Gallery, San Francisco
Galerie Alexandre Iolas, Paris
1971 *Books*, Nigel Greenwood, London
Drawings, Contract Graphics Gallery, Houston
1972 Corcoran & Corcoran Gallery, Coral
Gables, Florida
Colored People, Leo Castelli, New York
D-M Gallery, London
Ed Ruscha: Drawings, Leo Castelli, New York
Ed Ruscha: Books and Prints, Mary Porter
Sesnon Gallery, University of California,
Santa Cruz
Janie C. Lee Gallery, Dallas
Minneapolis Institute of Arts
1973 Ace Gallery, Los Angeles
Books by Ed Ruscha, University of California,
San Diego
Ed Ruscha: Drawings, Leo Castelli Gallery,
New York
*Edward Ruscha: Graphics from the Collection of
Donald Marron*, Leo Castelli Gallery, New York

Edward Ruscha: Projection, Ursula Weavers,
Cologne
Stains: Edward Ruscha, Françoise Lambert,
Milan
*Edward Ruscha (Ed-werd Rew-shay) Young
Artist*, John Berggruen Gallery, San Francisco
Nigel Greenwood Inc., London
1974 *Works by Edward Ruscha*, Françoise Lambert,
Milan
Edward Ruscha: Prints and Books, Root Art
Center, Hamilton College, Clinton, New York
Golden West College, Huntington
Beach, California
Leo Castelli Gallery, New York
Recent Paintings, The Texas Gallery, Houston
1975 *Miracle* and *Premium* film screening, Fox
Venice Theater, Venice, California
Paintings, Drawings and film 'Miracle,' Galerie
Ricke, Cologne
Jared Sable Gallery Ltd, Toronto
Film preview, Leo Castelli, New York
Books, Northlight Gallery, Arizona State
University, Tempe
Tropical Fish Series, Gemini G.E.L, Los Angeles
1975 *Edward Ruscha: Drawings/ Selected Prints*,
The Glaser Gallery, La Jolla, California
*Edward Ruscha: Prints and Publications 1962–
74*, The Arts Council of Great Britain.
Travelled to twelve Arts Council member
galleries; Northern Kentucky State University,
Highland Heights; Ace Gallery, Los Angeles
Various Miracles, Ace Gallery, Los Angeles
1976 Ace Gallery, Vancouver
Exhibitions and Presentations, Los Angeles
Institute of Contemporary Art
Institute of Contemporary Art, London
*Paintings, Drawings, and Other Work by Ed
Ruscha*, Albright-Knox Art Gallery, Buffalo,
New York
Sable Castelli Gallery Ltd., Toronto
Stedjelik Museum, Amsterdam
Various Cheese Series, Gemini G.E.L., Los Angeles
1977 *Drawings by Joe Goode and Edward Ruscha*,
The Texas Gallery, Houston
Recent Paintings, Ace Gallery, Venice,
California and Los Angeles
Edward Ruscha: Recent Drawings, Elmwood
Arts Foundation and The Fort Worth Art
Museum, Fort Worth, Texas
Prints and Books, University of Lethbridge,
Alberta; University of Calgary Art Gallery
1978 *A Selection of Paintings and Pastels 1974–1977*,
MTL Gallery, Brussels
Drawings and Prints, Castelli Uptown, New York
Edward Ruscha: Books, Rüdiger Schöttle,
Munich
Ed Ruscha/Prints and Drawings, Getler/ Pall
Gallery, New York
Ed Ruscha: Recent Paintings and Drawings,
Ace Gallery, Vancouver

Galerie Ricke, Cologne
Graphic Works by Edward Ruscha, Auckland
City Art Gallery
1979 *Edward Ruscha: New Works*, The Texas
Gallery, Houston
Neue Ausstellungen im InK, InK, Halle für
internationale neue Kunst, Zurich
Edward Ruscha: New Works, Marianne Deson
Gallery, Chicago
Edward Ruscha: New Works, Richard Hines
Gallery, Seattle
1980 *Edward Ruscha: Paintings*, Ace Gallery,
Venice, California
Edward Ruscha: Paintings and Drawings,
Portland Center for the Visual Arts, Portland
Nigel Greenwood, Inc., London
New Paintings, Leo Castelli Gallery, New York
Ruscha: Selected Works 1966–1980, Foster
Goldstrom Fine Arts, San Francisco
1981 Ace Gallery, Vancouver
Edward Ruscha: New Works, ARCO Center of
Visual Arts, Los Angeles
Edward Ruscha: Drawings, Leo Castelli, New York
1982 *Edward Ruscha: A Selection of Drawings from 1967
to 1972*, John Berggruen Gallery, San Francisco
Edward Ruscha: New Drawings, Castelli
Uptown, New York
Edward Ruscha: 1960–1970, Castelli, Feigen,
Corcoran, New York
New Paintings and Drawings, Flow Ace
Gallery, Los Angeles
The Works of Ed Ruscha (retrospective), San
Francisco Museum of Modern Art. Travelled
to The Whitney Museum of American Art,
New York; Vancouver Art Gallery, Canada;
San Antonio Museum of Art, Texas; Los
Angeles County Museum of Art
1983 *New Drawings*, Bernard Jacobson Gallery,
Los Angeles
*Ed Ruscha: Selection of Graphic Works, 1970–
1982*, Cirrus Editions Ltd, Los Angeles
Drawings, Galleria Del Cavallino, Venice
1984 *New Paintings*, Leo Castelli, New York
1985 Fischer Gallery, University of Southern
California, Los Angeles
Ed Ruscha: Quelques Dessins, Galerie Gilbert
Brownstone, Paris
New Paintings, James Corcoran Gallery, Los
Angeles
Octobre des Arts, Musée St.-Pierre, Lyon
Tanja Grunert, Cologne
1986 *New Paintings*, Fuller Goldeen Gallery, San
Francisco
New Paintings, Leo Castelli Gallery, New York
Texas Gallery, Houston
4x6, Westfälischer Kunstverein, Munster
1987 *Edward Ruscha: Drawings 1962–1972*, Acme
Art, San Francisco
Drawings through the Years, Cirrus Gallery,
Los Angeles

Edward Ruscha: 35 Lunette Paintings – Commissioned by Metro-Dade Art in Public Places Trust for Miami Dade Public Library, Leo Castelli Gallery, Greene Street, New York
New Paintings, Robert Miller Gallery, New York
The Works of Ed Ruscha, Contemporary Arts Museum, Houston

1988 *Early Paintings*, Tony Shafrazi Gallery, New York
Edward Ruscha: Recent Paintings, Museum of Contemporary Art, Chicago
Edward Ruscha: Recent Works on Paper 1988, Karsten Schubert, Ltd., London
Prints, Gallery Takagi, Nagoya
New Paintings and Drawings, Institute of Contemporary Art, Nagoya
New Drawings, Leo Castelli Gallery, New York
Words Without Thoughts Never to Heaven Go: Works related to the Miami-Dade Public Library Commission for Metro-Dade Art in Public Places, Lannan Museum, Lake Worth, Florida. Travelled to Williams College Museum of Art, Williamstown, Massachussetts

1989 *'Dreams' and Other Works on Paper*, Leo Castelli Gallery, New York
New Paintings and Drawings, Tokyo Museum of Contemporary Art
Edward Ruscha: Selected Works of the 80s, James Corcoran Gallery, Santa Monica
Ed Ruscha: New Paintings and Works on Paper, Rhona Hoffman Gallery, Chicago
New Paintings, Leo Castelli Gallery, New York
Edward Ruscha (retrospective), Musée National d'Art Moderne, Centre Georges Pompidou, Paris. Travelled to Museum Boymans-van Beuningen, Rotterdam, The Netherlands; Centre Cultural de la Fundació la Caixa, Barcelona; Serpentine Gallery, London; Museum of Contemporary Art, Los Angeles (through 1991)

1990 Ed Ruscha: New Paintings and Drawings, Karsten Schubert, London
Edward Ruscha: Paintings and Drawings, Texas Gallery, Houston
Los Angeles Apartments, The Whitney Museum of American Art, New York
Ed Ruscha: Paintings, The Museum of Contemporary Art, Los Angeles
Paintings, Serpentine Gallery, London

1991 *Ed Ruscha: Paintings*, Leo Castelli Gallery, New York
Edward Ruscha: Recent Editions, Castelli Graphics, New York

1992 *Edward Ruscha: Stains*, Robert Miller Gallery, New York
Edward Ruscha: New Paintings & Drawings, Galerie Thaddaeus Ropac, Salzburg
Edward Ruscha: Cameo Cuts, Edition Julie Sylvester, New York

1993 *Edward Ruscha: Romance with Liquids*, Gagosian Gallery, New York
Edward Ruscha: Standard Stations, Amarillo Art Center
Edward Ruscha: New Work, Space Gallery, Casino Knokke, Brussels

1994 *A. James Speyer Memorial Lecture and 'Miracle' Film Presentation*, The Art Institute of Chicago

1995 *Anamorphic Paintings*, Leo Castelli Gallery, New York
Sayings, Leo Castelli Gallery, 578 Broadway, New York
The End, Close Range Gallery, Denver Art Museum

1996 *Ed Ruscha*, Kantor Gallery, Los Angeles
VOWELS: Paintings on Book Covers, Gagosian Gallery, Beverly Hills
Edward Ruscha, Gallery Seomi, Seoul

1997 *Spaghetti Westerns*, Milwaukee Art Museum
Edward Ruscha: Cityscapes/ O Books, Leo Castelli, New York

1998 *Retrospective of Works on Paper by Edward Ruscha*, J. Paul Getty Museum, Los Angeles
New Paintings, Gagosian Gallery, Beverly Hills
Inventors, Boxers, Racecar Drivers, Artists, Etc., Marian Goodman Gallery, Paris.
Ed Ruscha: New Paintings and a Retrospective of Works on Paper, Anthony d'Offay Gallery, London

1999 *Metro Plots*, Gagosian Gallery, New York
Works on Paper, Susan Sheehan Gallery, New York
Edward Ruscha: Editions 1959–1999, Walker Art Center, Minneapolis. Travelled to Los Angeles County Museum of Art; University of South Florida Contemporary Art Museum, Tampa (through 2001)
Edward Ruscha, Kukje Gallery, Seoul
Ed Ruscha, Metta Galeria, Madrid

2000 *Mountains and Highways*, Anthony d'Offay Gallery, London
Edward Ruscha: Retrospective, Hirshhorn Museum and Sculpture Garden, Washington, D.C.
Ed Ruscha: Gunpowder and Stains, Monika Sprüth-Philomene Magers, Munich
Powders, Pressures and Other Drawings, John Berggruen Gallery, San Francisco;

2001 *Sunliners*, Richard Levy Gallery, Albuquerque
NOVANTA, Galleria Il Gabbiano, Rome
Ed Ruscha: The Mountains, Inverleith House, Royal Botanic Garden, Edinburgh

2002 *With and Without Words*, Monika Sprüth Philomne Magers, Munich (through 2003)
Ed Ruscha: Made in Los Angeles, Museo Reina Sofia, Madrid
Paintings, Gagosian Gallery, Chelsea, New York
Ed Ruscha: Birds, Fish, and Offspring, C&M Arts, New York
Country Cityscapes, Susan Inglett Gallery, New York
Ed Ruscha: Paintings, Drawings and Books 1961–2001, Museum of Modern Art Oxford; California Palace of the Legion of Honor, San Francisco; Galeria Andre Viana, Porto
S Books, O Books, and Other Books, James Kelly Contemporary, Santa Fe

2003 *Ed Ruscha Prints 1969–2003*, Godt-Clearly Gallery, Las Vegas, Nevada
Ed Ruscha: Photographs, Gagosian Gallery, Beverly Hills

2004 *Witty Wonders from Anagrams to Gunpowder and All the Parking Lots on Sunset Strip*, The Whitney Museum of American Art, New York
Ed Ruscha: Paintings, Drawings, Photographs, Books, Scottish National Gallery of Modern Art, Edinburgh (through 2005)
Edward Ruscha: 80s & 90s Paintings and Prints, Ishizaka Art, Tokyo
Ed Ruscha: New Drawings, Gagosian Gallery, New York
Cotton Puffs, Q-Tips®, Smoke and Mirrors: The Drawings of Ed Ruscha, The Whitney Museum of American Art, New York. Travelled to Museum of Contemporary Art, Los Angeles; National Gallery of Art, Washington, D.C. (through 2005)
Ed Ruscha, Museum of Contemporary Art, Sydney. Travelled to the Museum of Contemporary Art, Rome; National Gallery, Berlin
Ed Ruscha: Mountain Paintings, the Aspen Art Museum, Colorado

2005 *Ed Ruscha: Then & Now*, Gagosian Gallery, Beverly Hills
Ed Ruscha: New Drawings, Gagosian Gallery, Rome
Ed Ruscha: Course of Empire, 51st Venice Biennale, US Pavilion. Travelled to The Whitney Museum of American Art, New York (through 2006)
Ed Ruscha: Paintings and Works on Paper From 1964–2002, Fisher Landau Center for Art, Long Island City, New York

2006 *Ed Ruscha: Early Prints*, Norton Simon Museum, Pasadina (through 2007)
Ed Ruscha: Signs+Streets+Streets+Signs, Crown Point Press, San Francisco
Ed Ruscha: La mirada distanciada, Museo Tamayo Arte Contemporáneo, Mexico City
Ed Ruscha: Drawings, Gagosian Gallery, New York
Ed Ruscha, Photographer, Jeu de Paume, Paris; Kunsthaus Zurich; Museum Ludwig, Cologne

2007 *Ed Ruscha: Busted Glass*, Gagosian Gallery, London

2008 *Ed Ruscha: Paintings*, Gagosian Gallery, London

Books by Ed Ruscha

1963 *Twentysix Gasoline Stations*. First edition of 400 numbered copies; second edition, 1967, 500 copies; third edition, 1969, 3,000 copies: 17.8 x 14 x 0.6 (7 x 5½ x ¼).

1964 *Various Small Fires and Milk*. First edition of 400 copies, 50 were signed by the artist; second edition, 1970, 3,000 copies: 17.8 x 14 x 0.6 (7 x 5½ x ¼).

1965 *Some Los Angeles Apartments*. First edition of 700 copies; second edition, 1970, 3,000 copies; third edition, 1971, 5,000 copies: 19.1 x 14.6 x 1.6 (7½ x 5 ¾ x 5/8).

1966 *Every Building on the Sunset Strip*. First edition of 1,000 copies; second edition, 1969, 500 copies: 17.8 x 14 x 0.6 (7 x 5½ x ¼).

1967 *Thirty-four Parking Lots in Los Angeles*. First edition of 2,500 copies; second edition, 1974, 1,913 copies: 25.4 x 20.3 x 0.6 (10 x 8 x ¼). *Royal Road Test*. In collaboration with Mason Williams and Patrick Blackwell. First edition of 1,000 copies; second edition, 1969, 1,000 copies; third edition,1971, 1,000 copies; fourth edition, 1980, 1,500 copies: 24.1 x 16.5 x 0.6 (9 ½ x 6½ x ¼).

1968 *Nine Swimming Pools and a Broken Glass*. First edition of 2,500 copies: 17.8 x 14 x 0.6 (7 x 5 ½ x ¼).

1968 *Business Cards*. Edition of 1,000 copies signed by the artist and his collaborator, Billy Al Bengston: 22.2 x 14.6 x 0.6 (8 ¾ x 5 ¾ x ¼).

1969 *Stains*. Hollywood: Heavy Industry Publications. Signed and numbered edition of 70 copies. *Crackers*. Hollywood: Heavy Industry Publications. Story by Mason Williams; edition of 500 copies: 22.2 x 15.2 x 1.3 (8 ¾ x 6 x ½).

1970 *Babycakes*. New York: Multiples, Inc. Edition of 1,200 copies: 19.1 x 15.2 x 1.3 (7 ½ x 6 x ½). *Real Estate Opportunities*. Edition of 4,000 copies: 17.8 x 14 x 0.6 (7 x 5 ½ x ¼).

1971 *A Few Palm Trees*. Hollywood: Heavy Industry Publications. Edition of 4,000 copies: 17.8 x 14 x 0.6 (7 x 5 ½ x ¼). *Records*. Hollywood: Heavy Industry Publications. Edition 2,000 copies: 17.8 x 14 x 0.6 (7 x 5 ½ x ¼).

1972 *Colored People*. Edition of 4,000 copies: 17.8 x 14 x 0.6 (7 x 5 ½ x ¼).

1978 *Hard Light*. Hollywood: Heavy Industry Publications. Edition of 3,500 copies, in collaboration with Lawrence Weiner: 17.8 x 12.7 x 0.6 (7 x 5 x ¼).

Films by Ed Ruscha

1970 *Premium*. New York: Castelli-Sonnabend, 24 min., color, magnetic sound, 16 mm.

1975 *Miracle*. New York: Castelli-Sonnabend, 28 min., color, optical sound, 16 mm.

Selected Books and Catalogues

Primary sources are the three catalogue raisonnés of Ruscha's paintings: *Volume One: 1958–1970*, with essays by Yve-Alain Bois and Walter Hopps; *Volume Two: 1971–1982*, with essays by Reyner Banham and Peter Wollen; and *Volume Three: 1982–1987* with essays by Lawrence Weiner, Dave Hickey and Robert Dean, Göttingen and New York 2004, 2005 and 2007. The paintings are catalogued online at www.edruscha.com, and further volumes will be published over the coming years. A catalogue raisonné of works on paper, edited by Rainer Crone and Petrus Graf Schaesberg, is scheduled for publication in 2009.

Other key books on Ed Ruscha include the excellent compilation of statements and interviews, Alexandra Schwartz (ed.), *Leave Any Information at the Signal*, Cambridge, Mass. 2002 and Richard Marshall's monograph *Ed Ruscha*, London 2003.

See notes on p.123 for key exhibition catalogues and other source material.

Copyright credits

Photographic Credits

Index